JAPANESE NETSU

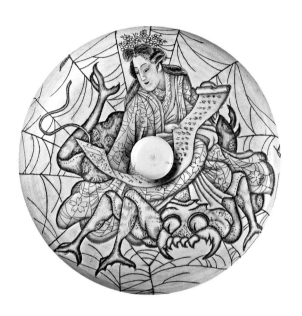

JAPANESE NETSUKE

JULIA HUTT

Photography by Ian Thomas and Richard Davis

V&A Publishing

This book is dedicated to H.I.H. Prince Norihito Takamado (1954–2002),
who worked tirelessly to raise public awareness of netsuke
and made a significant contribution to the subject.

First published by V&A Publishing, 2003
This edition published, 2019
V&A Publishing
Victoria and Albert Museum
South Kensington
London SW7 2RL
www.vandapublishing.com

Distributed in North America by Abrams, an imprint of ABRAMS

Julia Hutt asserts her moral right to be identified as author of this book.

ISBN 978 1 85177 922 2

10 9 8 7 6 5 4 3 2 1
2023 2022 2021 2020 2019

Designer: Andrew Shoolbred
Cover design: Joe Ewart, Society

V&A photography by Ian Thomas and Richard Davis, V&A Photographic Studio

A catalogue record for this book is available from the British Library

Front: Tiger on a bamboo stem (see pl. 38)
Back: The Chinese General Gentoku (see pl. 66)

Half-title: *Manjū* netsuke (see pl. 68)
Frontispiece: *Ryūsa* netsuke. Autumn plants by the moon. Ivory
Signed 'Kōu'. 19th century. D. 4.5cm. A.1016-1910. Salting Bequest

Printed in Hong Kong by Great Wall Printing Co Ltd.

V&A Publishing
Supporting the world's leading
museum of art and design,
the Victoria and Albert
Museum, London

GENERAL NOTES
Japanese Netsuke is not a catalogue but a book
about netsuke, illustrated largely by material
from the V&A. In the majority of cases, dating
netsuke is not precise – the method adopted
in this book corresponds with that used in the
Toshiba Gallery of Japanese Art at the V&A.
Unless a netsuke can be ascribed to a specific
century, the term is avoided and the appella-
tions '1750–1850' or '1775–1850', for example,
are used instead. It must be emphasized that
they are, for the most part, approximate
dates.

All old Japanese books referred to in the
text or captions are given an English title. This
may not be a direct translation, but the popu-
lar name by which it is known, or simply an
indication of its contents.

NOTES ON JAPANESE NAMES AND
PRONUNCIATION
Japanese names are either given in the
Japanese order, that is family name followed
by given name, or in the form by which they
are most commonly cited, usually the given
name or the art name (*gō*).

Consonants in Japanese words are pro-
nounced much as they are in English, vowels
as they are in Italian. There is a difference,
however, between the short and the long u /
ū and o / ō, the macron over the vowel indi-
cating the longer form. The shorter u is pro-
nounced as in 'cruet', the longer ū as in 'boot'.
The shorter o is pronounced as in 'hot', the
longer form ō as in 'ought'. Macrons are used
throughout the text except on the frequently
occurring place names Tokyo, Kyoto, Osaka
(strictly Tōkyō, Kyōto and Ōsaka).

Contents

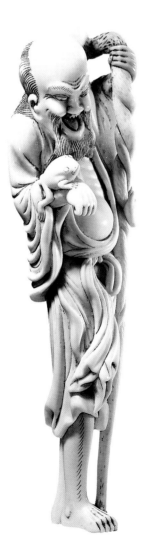

Foreword
EDMUND DE WAAL

Who could not love netsuke? When you open a book and see a picture of a netsuke it is difficult to gauge its size. It sits on the page, this intense tumble of brown rat chewing its tail (Plate 3), an ivory octopus caught in a trap (Plate 95), and all you are aware of is that this is a photograph of something very small. You want to bring it closer still. A first instinct is to temper your disbelief that anything so small could be so intricate and yet so expressive. The rat's fur lying along its bony back and the slinkiness of its tail are so apparent that you simply cannot comprehend how the carver achieved this fidelity to what they have seen or imagined. How is it possible to make an octopus seem melancholy?

This is a book that takes the immediacy of that delight on seeing these small sculptures and brings alive the reasons they were made, the depth of the subjects they represent and the fugitive knowledge of the people who spent so many hours making them. It is a book that achieves the almost impossible task of creating a context for objects that do not seem to need one.

Netsuke can deal with very large subjects. Not just big subjects – look at the netsuke of the ox by Tomotada (Plate 96) and you can feel the heaviness, the tiredness, the mass of this animal – but subjects of gravitas. These can be mythological subjects, depictions of great generals or moments of drama. However it is the intimacy of the caught moment or an unexpected encounter where we see the greatness of the

❙ The author's netsuke on display. Ephrussi Collection.

form, rather like *haiku*, the traditional 17-syllable poetic form that celebrates fleeting perceptions and images. For that reason netsuke very rarely seem to be of an animal or person at rest. Netsuke seem to demand activity – an element of motion. This makes sense of their tactility; your fingers are able to discover the slipperiness of a snake's scales (Plate 16) or the feet of a centipede sliding its way along a boar's tusk (Plate 30). But it can also work with some of the human subjects, such as Taira no Tadamori mistakenly attacking the oil thief, a fight in which we might know the outcome but all seems to be at stake (Plate 53). In the wonderful netsuke of the pillar in the Daibutsuden in Nara, a woman is climbing through the hole, whilst a man stands on his friend's back, waiting his turn (Plate 43). It is a comedy of size, a comedy of fit. It is also one of the recurrent puns of a netsuke carver – the making of a sculpture about holes. In handling netsuke I am often aware of the subtlety of these plays on function or on materiality. In making a netsuke of a dead fish or a fruit on the point of deliquescence, the sculptor is playing with our feelings for the hardness or softness of the world – and our desire to interact with it. What this book also reveals is the mixture of materials used by the carvers, from the inlaid eyes of a tiger (Plate 105) to the coloured buttons on the netsuke of a standing European woman (Plate 28).

My own involvement with netsuke began through an inheritance of a family collection (Plate I). It had been bought in Paris in the 1870s, had remained intact through extraordinary vicissitudes and travels to Vienna and to Tokyo. In my years of researching *The Hare With Amber Eyes*, a book on this collection, I became conscious of the ways in which these objects had become important to different members of my family, from collectors to children (Plate II). It struck me that there are few art forms that could have had this reach. My travels also mapped the sheer number of people in the West who had succumbed to a fascination with them. The very first collectors in the nineteenth century, during the groundswell of *Japonisme*, included novelists and artists. These carvings seemed to express Japan *tout court*, ribald, erudite, erotic, tender, tragic. To own a collection of them was to own Japan. To collect other kinds of Japanese art one may have needed great knowledge, but netsuke seemed to present themselves as lacking any hinterland. There was no literature available and it seemed no erudition was required. And they could slip easily into the vitrines housing the bibelots that were part of salon life.

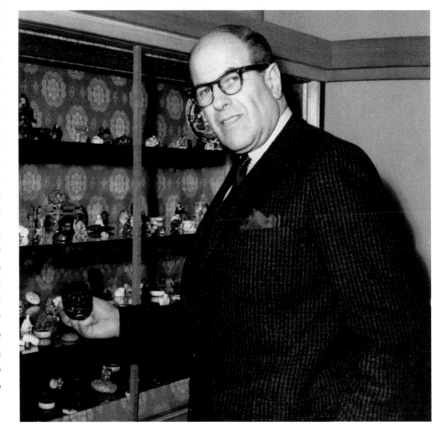

II Ignace von Ephrussi with his netsuke collection, Tokyo, 1960. Ephrussi Collection.

There then came a generation of collector-scholars who spent considerable energy in proving the deficiencies of these pioneer owners. The start was with Albert Brockhaus in 1905, the lonely German scholar who expressed so plaintively his wish for conversation over his collection – as well as his anxiety over the carelessness of domestics in dusting his precious netsuke. Then came the first books in English by F.M. Jonas in 1928. These are the serious pioneer guides, staking their claim. Following this comes the middle 'dextrous' period of writing on netsuke, the guides for soldiers and tourists to Japan after the war. In these, netsuke are used as example of Japanese folklore or mythology. Then belatedly, comes the 'Art' period, in which attention is given to the aesthetics of the object. It starts with Frederick Meinertzhagen in 1956 with *The Art of the Netsuke Carver* and continues into the 1970s, with books that glory in colour reproductions of the lustrous patinas. This was when the lavish *Collector's Netsuke*, by an American lawyer and collector Raymond Bushell, was first published: 'Here I explore matters of importance to the sophisticated collector – for example, copies and copying, age and authenticity... rectify misinterpretations...'. In the 1970s there was the foundation of the International Netsuke Society, a growth in specialist dealers, the first sales at auction-house and group visits of collections in Japan. And now there is the dissemination of knowledge that allows us to see netsuke as much more than a rarified, coded, complex art form to be locked away in cabinets. It allows us to approach them with delight.

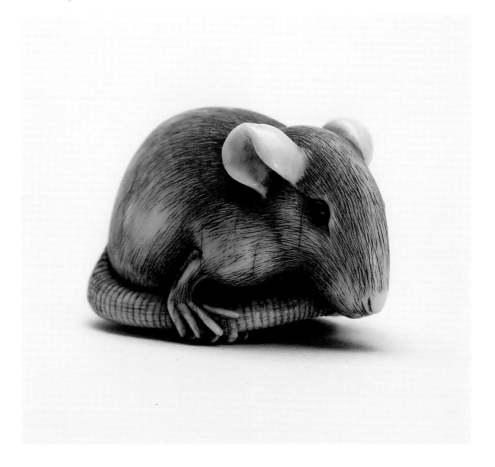

III The rat: Ivory netsuke of a rat clutching its tail. Signed Mitsutada, Kyoto. *c.* 1800.

This is a delight expressed by Rudyard Kipling in a letter from Japan in 1889 about his travels. He is with his friend, the Professor:

'What does it matter?' said the Professor. 'Here's a shop full of the wrecks of old Japan. Let's go in and look.'

The Professor raves about the cabinets in old gold and ivory studded with jade, lazuli, agate, mother-o'-pearl and cornelian, but to me more desirable than any wonder of five-stoned design are the buttons and netsuke that lie on cotton wool, and can be taken out and played with. Unfortunately the merest scratch of Japanese character is the only clue to the artist's name, so I am unable to say who conceived, and in creamy ivory executed, the old man horribly embarrassed by a cuttle-fish; the priest who made the soldier pick up a deer for him and laughed to think that the brisket would be his and the burden his companion's; or the dry, lean snake coiled in derision on a jawless skull mottled with the memories of corruption; or the Rabelesian badger who stood on his head and made you blush though he was not half an inch long; or the little fat boy pounding his smaller brother; or the rabbit that had just made a joke; or – but there were scores of these notes, born of every mood of mirth, scorn and experience that sways the heart of man; and by this hand that has held half a dozen of them in its palm I winked at the shade of the dead carver! He had gone to his rest, but he had worked out in ivory three or four impressions that I had been hunting after in cold print.

The Englishman is a wonderful animal. He buys a dozen of these things and puts them on top of an overcrowded cabinet, where they show like blobs of ivory, and forgets them in a week. The Japanese hides them in a beautiful brocaded bag or a quiet lacquer box till three congenial friends come to tea. Then he takes them out slowly, and they are looked over with appreciation amid quiet chuckles to the deliberative clink of cups, and put back until the mood for introspection returns. That is the way to enjoy what we call curios. Every man is a collector in Japan, but you shall find no crowds of 'things' outside of the best shops.

So take out a book on netsuke – or, if you are fortunate, a real one – and look at it with deliberation (Plate III). Or go to a museum and wander past the cabinets of netsuke and look at a single one. Let your eyes settle. You will have both a moment of quiet delight and a mood of introspection to carry away.

1 | Netsuke: An Introduction

The netsuke is one of the most well known and popular forms of Japanese art in the West. It is easy to understand why: netsuke have immediate appeal and can be easily understood, while they often also embody a lively sense of humour. They are carved with consummate skill, displaying meticulous attention to the detail of the subject fully in the round, which is especially remarkable considering how small they are. Indeed, for many people, one of the most alluring characteristics of netsuke is their size, and it is this that also makes them intrinsically suitable for collecting.

Among the often unfamiliar language associated with Japanese art history, 'netsuke' is one of the very few Japanese art historical terms that merits its own entry in *The Concise Oxford Dictionary*, the foremost authority on current English. Furthermore, on account of its widespread acceptance into the English language, the word is excluded from the standard convention of italicizing or underlining foreign terms. Despite its widespread familiarity, however, it is commonly mispronounced, with most people who do not know the Japanese language stressing the 'u' and turning the final 'e' into an 'i'. In Japanese, however, the 'u' of netsuke is mute, with equal emphasis being placed on 'nets' and 'ke'; the latter 'e' is pronounced as in the French *accent aigu* (é) or the 'ke' as in the Spanish 'que', resulting in a pronunciation of 'nets'ké'.

One of the purposes of this short chapter is to explain briefly the function of the netsuke, provide a historical context and introduce basic terminology. Since the traditional Japanese garment, the kimono, did not include pockets, other means were devised to carry around items of daily use. This varied from using the often-capacious sleeves of the kimono, to tucking articles into the breast folds. It was the sash (*obi*), however, which was secured round the waist and used to hold the kimono together, that became the focal point for carrying objects. This was achieved most simply by tucking items, such as a fan, into the sash. Alternatively various pouches, containers or miscellaneous items, known collectively as *sagemono* ('hanging things'), were suspended from the sash (Plate 1). Most notable of these were the money pouch (*kinchaku*), smoking accessories, including the tobacco pouch (*tabakoire*) (Plate 7), tobacco box (*tonkotsu*), pipe (*kiseru*) and pipecase (*kiseruzutsu*) and, in particular, the *inrō* ('seal basket') (Plate 2).

Sagemono were used by all strata of society, most notably the *chōnin* (townspeople), but only by men. The Tokugawa regime, which ruled Japan between 1603 and 1868, created a rigid social hierarchy composed of four classes. Since craftsmen and merchants were seen as the least productive, they were, in descending order, placed in the third and fourth classes respectively. In practice, they were not readily differentiated and tended to form a single group, the *chōnin*. Denied political aspirations, but with money increasingly concentrated in their hands, they expressed themselves through the conspicuous

Opposite: Detail from Plate 3.

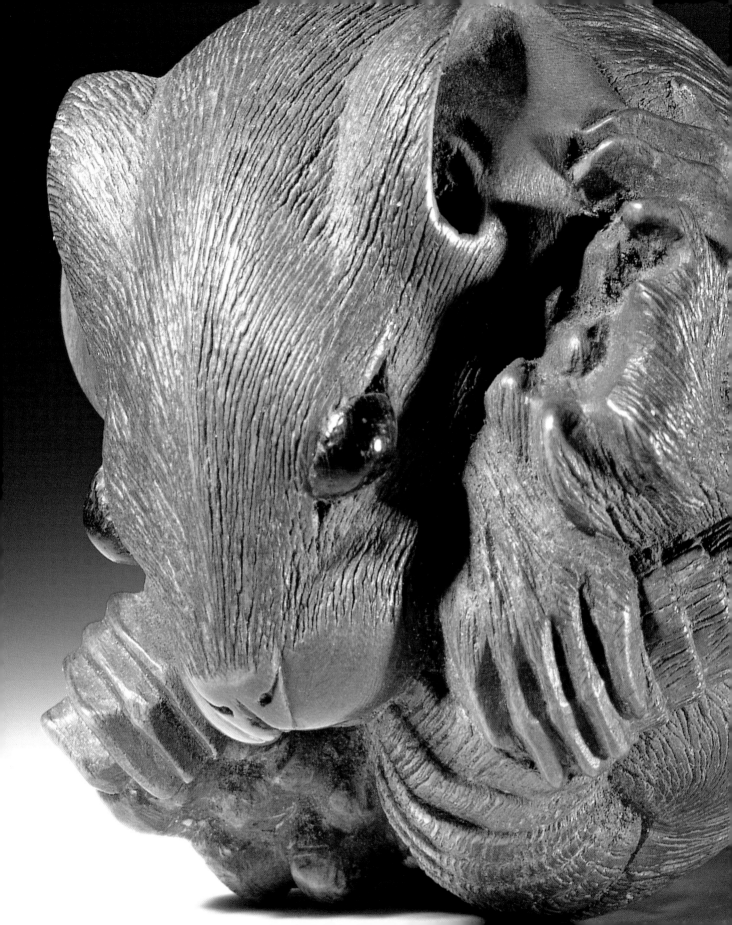

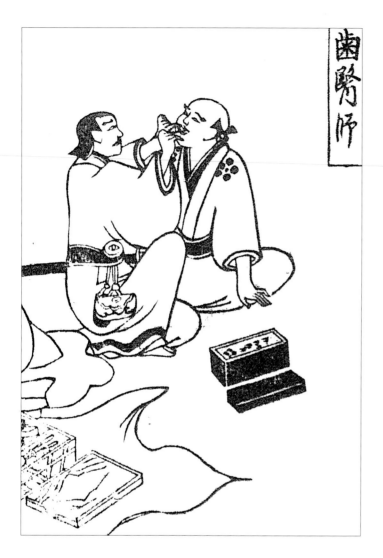

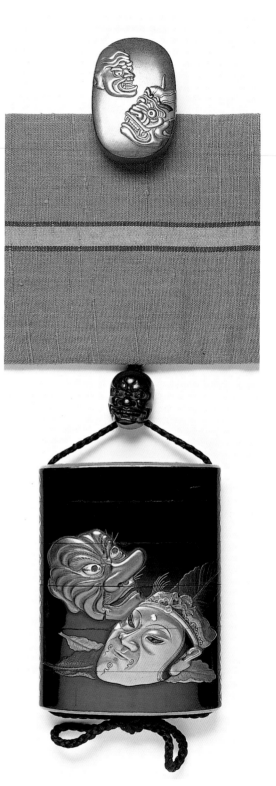

1 *The tooth-drawer and patient* (detail). The tooth-drawer wears a pouch and an *inrō* attached to the same *kara* netsuke, which hangs over the sash. The netsuke clearly shows some manner of bulky knot or 'plug'. From *Jinrin kinmō zui* ('Pictorial encyclopaedia of mankind'), illustrated by Makieshi Genzaburō. Woodblock-printed book, published 1690. Kress Archives.

2 *Inrō* ensemble hanging from a sash. Masks. *Inrō*: Black lacquer with gold *takamakie*. H. 8.3cm. *Hako* netsuke: Brown lacquer with gold *takamakie*. Signed 'Tōkei'. *Ojime*: Wood. Signed 'Jugyoku'. 1775–1850. W.221-1922. Pfungst Gift.

consumption of material goods. Dress played a crucial role in this, despite the repeated promulgation of sumptuary regulations against overt displays of wealth that were not appropriate to an individual's rank. Whereas male attire was somewhat restrained and sober compared to that of women, men displayed their taste in the choice of fashionable dress accessories, particularly *inrō* and netsuke. It was precisely the small size of *sagemono*, moreover, that enabled *chōnin* to wear costly and elaborate examples without drawing attention to the fact, since the circumvention of such laws was an important part of urban chic.

All items of *sagemono* were provided with the means to hang them from the sash. In the case of *inrō*, a pair of cord channels (*himotōshi*) on either side of the body allowed a continuous silk cord to be threaded through, down the channel on one side and up through the other. The two cord ends at the top of the *inrō* body were then threaded through an *ojime* ('cord tighten'), which was most commonly in the form of a spherical bead. The *ojime* helped to keep the sections of the *inrō* firmly together, so that its contents could not spill out. This was achieved by pulling the *ojime* down as far as it would go towards the *inrō* body, tightening the cord around the sections. When the *ojime* was drawn upwards, the tension on the cord slackened and the sections could be separated.

With the pouch or container positioned below the sash, the two cords were passed behind it; they were then attached to a netsuke or toggle, often in the form of a small carving, which lay over the upper part of the sash (Plate 78). The sash was tightened around the kimono and the bulk of the netsuke, however slight, helped prevent the pouch or container from falling to the ground. By simply pushing the netsuke down behind the sash, pulling down with it the cord and container, a man had comparatively easy access to his smoking paraphernalia, *inrō* or other items of *sagemono*. Although the pouches or containers, *ojime* and netsuke were all important objects in their own right, none could function in a true sense without the others. It is for this reason that the term 'inrō ensemble' has often been used to describe its three main components, the *inro*, *ojime* and netsuke, and to express their inter-dependence.

Netsuke were first and foremost functional objects and, in order to be considered true netsuke, had to comply with certain basic requirements that also imposed practical limitations on them. A netsuke needed to be comparatively small and not too heavy, while at the same time having sufficient size and bulk to prevent the suspended object from falling to the ground. It needed to be reasonably compact, with no sharp protrusions or corners that might snag the fabric of the sash or kimono (Plate 3). Strong and durable materials were highly desirable, so that the netsuke would not get damaged or break easily through repeated use. One of the most important prerequisites of the netsuke, however, was to provide the means of attaching and securing the cord of the *sagemono*. This was generally achieved either by a pair of cord channels (*himotōshi*), an eyelet or loop on the back, underside or inside of the netsuke, which was to be as unobtrusive as possible. Alternatively, a natural opening could serve the same purpose; by skilful planning and design, this could be achieved with an arm or leg of a figure bent against another part of the body, for example. The cord holes or loop, moreover, needed to be positioned so that the netsuke faced the front in exactly the manner the *netsukeshi* (netsuke craftsman) intended. Although the netsuke was seen from a fixed point when worn, it was nevertheless conceived completely in the round.

3 Curled rat. Wood with inlaid eyes. Signed 'Masanao'. 1850–1900. H. 4.1cm.
A.50-1919. Clarke-Thornhill Gift.

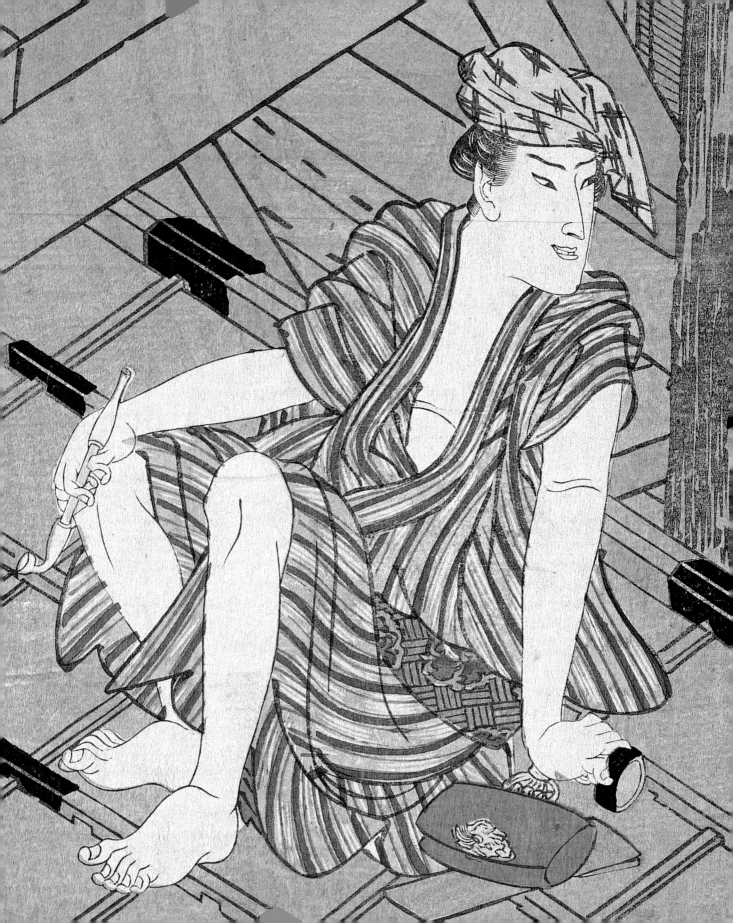

Traditional Japanese literature on the subject of netsuke is almost non-existent. The one exception is *Sōken kishō* ('Strange and wonderful sword fittings'), by Inaba Tsūryū Shin'emon and first published in Osaka, 1781. As the title implies, it was primarily intended as a guide to the appreciation and connoisseurship of swords and related metalwork, including genealogies of famous sword-makers. Of the seven volumes that make up this work, the last comprises a supplement on netsuke, with additional sections on *inrō* and *ojime*. It contains a list of 54 *netsukeshi*, together with short biographies that sometimes include the various names they used, place of work and particular characteristics of their netsuke, along with their main occupation. This section also includes illustrations of works by some of the most important *netsukeshi* of the time. The information contained in *Sōken kishō* formed the backbone of netsuke studies in both Japan and the West until the twentieth century. On account of its considerable importance, it will be referred to throughout this book.

It was not until the mid-twentieth century that other works on netsuke began to appear. In Japan, the first was Reikichi Ueda's *Netsuke no kenkyū* ('The study of netsuke'), published in 1943; this was brought out in an English version in 1961 as *The Netsuke Handbook of Ueda Reikichi*, adapted from the Japanese by Raymond Bushell. Since this included not only the first authoritative account of netsuke, but also an index of 1,342 *netsukeshi*, with the reproduction of 185 signatures, it became the most useful reference work on the subject. Despite this highly important, seminal work, it was outside Japan that the main work on netsuke took place. Albert Brockhaus' *Netsuke: Versuch einer Geschichte der Japanischen Schnitzkunst* ('Netsuke: an attempt at a history of Japanese carving art') was first published in German in 1905, while the first book in English was *Netsuke*, by Frederick Jonas, published in 1928. In subsequent years, literature on netsuke has exploded; it is probably no exaggeration to say that there has been more written on netsuke outside Japan than any other subject of Japanese art. In addition, the phenomenal early interest in netsuke helped shape Frederick Meinertzhagen's mammoth creation of a card index of recorded netsuke, now held in the archives of the British Museum.[1] This comprised over 12,000 hand-written cards with drawings, opinions and comments. In more recent years, the contribution of modern Japanese scholarship, which has begun to use hitherto untapped Japanese sources such as local histories and gravestones, is proving extremely welcome and most valuable. Whereas Western countries took the lead in the study of netsuke during the twentieth century, the Japanese have now begun to redress this imbalance in the twenty-first century.

1 Some of this was published as Lazarnick (1986).

Detail of smoker from Plate 19.

2 | Origins and Early Development of Netsuke

Although netsuke as we know them today could not have existed before the appearance of *inrō* and other *sagemono* in the late sixteenth century, their origin is undoubtedly much earlier. The custom of suspending objects from a belt is common to many cultures of the world, including those of Central and East Asia. It is thought that the particular tradition which eventually gave rise to the netsuke started among nomadic groups of Western and Central Asia, gradually spreading to China, Korea and Japan in the East, as well as Hungary in the West. The relevance of the Hungarian connection will be discussed later in this chapter.

The belt with hangings had been used in China from an early date as an indication of status or rank, but it was during the Eastern Zhou Dynasty (770–221 BC) that it assumed greater importance. The belt hook, for example, first appeared at this time and has been excavated in large numbers from tombs of the Warring States period (475–221 BC). These years also saw increased contact between the Chinese peoples and the tribes of the northern borders, among whom belt hooks are thought to have originated before they were adopted into mainstream Chinese culture. These people were nomadic horsemen, and for practical reasons wore a tight-fitting, short jacket, long trousers, a belt and leather boots. The belt, which was fastened with a detachable hook, could also serve as a means of carrying practical items of everyday use, which were suspended from it.

This new style of dress, which was gradually adopted by the Chinese, was undoubtedly in part responsible for the popularity of the belt hook. The standard belt hook consisted of a head, generally in the form of an animal, a main body that was often arched, and a knob on the back. It was usually highly decorated, and was made from a wide variety of materials, such as bronze, silver and gold, that were often inlaid with gold, silver, jade, glass or turquoise. As well as fastening the belt, there is also evidence to suggest that belt hooks could be used to support a knife, sword, pouches or other personal items.[1] Not only were they practical, but they were in addition part of a conspicuous sartorial display that reflected the status of the wearer; this was apparent particularly in the material from which it was made. The codification of laws and regulations that governed what people of different rank were permitted to wear, including belts and hats, started in the late Zhou period, and continued essentially until the fall of imperial China in 1911.

It was the early combination of belt and attachments in China, together with the nomadic practice of suspending functional items from the belt, that largely shaped the subsequent development of belts and their accoutrements in East Asia. Belt hooks reached their peak of production in China around 300 BC, when they were largely superseded by a type of buckle that came from tribes to the west of China. The increasing

Opposite: Detail from Plate 5.

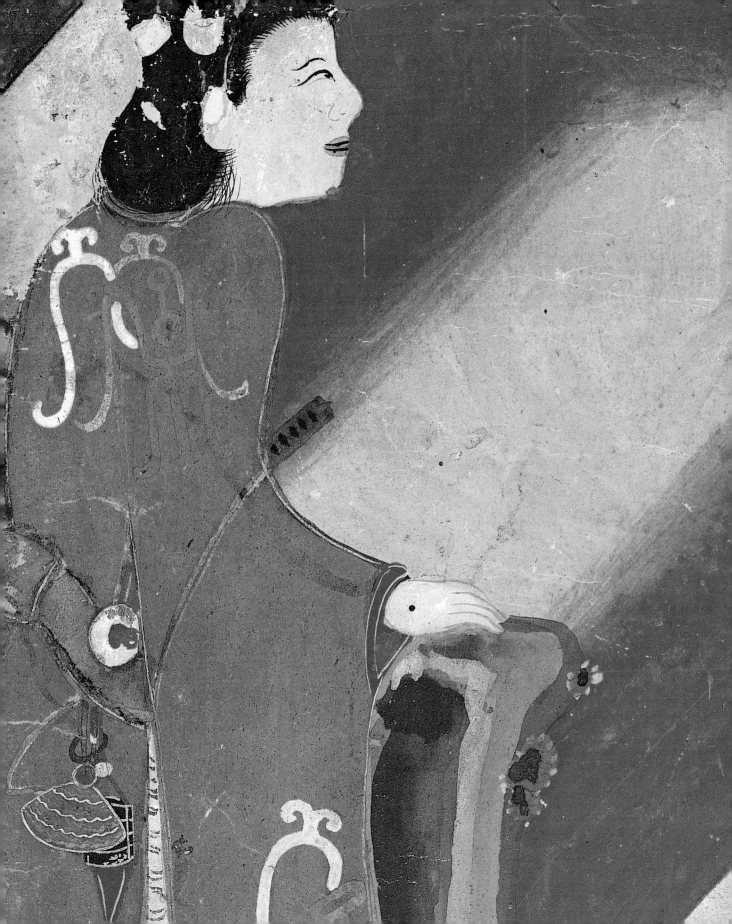

popularity of this buckle during the late Han Dynasty (206 BC – AD 221) led to the production of leather belts with decorative inlays or metal discs, and this type of belt subsequently formed the official belt in China until the twentieth century.[2] By the early Tang Dynasty (618–906), again under nomadic influence from Central Asia, the disc or plaques were given perforations at their base for hanging items of status as prescribed by the imperial court.[3] These included decorative strips and cords, to which were attached ornaments or functional and semi-practical objects, such as a dagger, flint-pouch and awl.[4] A later ninth-century painting from Khocho, which depicts Uighurian princes with belt hangings, illustrates that this practice was also a continuing tradition in Central Asia, where it originated.[5] Excavated material from Silla tombs, dating from between the fourth and fifth centuries, also attests to this tradition reaching Korea. The most spectacular examples are six elaborate gold belts, composed of gold plaques that were originally sewn on to a backing of leather or fabric.[6] Hanging from the belts at regular intervals are pendants made of interlinking ovoid plaques of sheet gold, terminating in curved jades (*kogok*), or practical and semi-decorative ornaments in gold. Although the custom of wearing belts and pendants to indicate status was not widespread in Japan, it was undoubtedly known. Among the treasures of the Shōsōin Imperial Repository at the Tōdaiji temple, Nara, dedicated in 756, is a leather belt with lapis lazuli and silver plaques, hanging from which are an incense pouch, knives and glass pendants.[7]

In Japan, however, the main legacy of the various customs relating to the belt and its hangings lay in the flint-pouch. According to the *Kojiki* ('Record of ancient matters'), which, completed in 720, is the oldest official history of Japan, Prince Yamato Takeru was sent to fight the barbarians in eastern Japan. Before setting out, he was presented with a sword and pouch, which he was told to open in an emergency. When he was later tricked and caught in a fire on a plain, he opened the pouch to find it contained fire-making equipment. He was thus able to save himself by using the sword and flint-pouch to start a counter-fire and keep the original fire at bay.[8] It was customary thereafter for travellers and soldiers to carry a flint-pouch (*hiuchi bukuro*).[9] This practice continued until the sixteenth century, when the *hiuchi bukuro* was largely superseded by the money pouch (*kinchaku*). The most basic method of carrying early pouches was undoubtedly by suspending them from the belt or sash, although they also appear to have been attached to the hilt of the small sword by natural objects, such as stones, shells or wood that resemble later netsuke.[10]

Throughout the course of Chinese history, contact with non-Chinese peoples had a paramount effect on the form of Chinese belts and their accessories. These underwent renewed influence, first under the Mongols during the Yuan Dynasty (1279–1368), then under the Manchu rule of the Qing Dynasty (1644–1911). Since horse-riding played an important part in the lives of the Mongols and Manchus, like their nomadic predecessors of the Zhou period they traditionally used various pouches to carry around the practical items their lifestyle required, such as flints and knives. Following on from earlier traditions established by the Tang Dynasty, Mongol and Manchu aristocrats wore formal and semi-formal belts fitted with metal rings at either side. These originally enabled the suspension cords of various items to remain securely attached while they were on horseback.

In China and, to a lesser extent, in Korea the practice of hanging accessories from the belt continued up until the twentieth century, when the inclusion of pockets in clothing rendered it superfluous. In China belt hangings were used by both men and women, regardless of age or rank, although those used by men were more numerous and often more highly decorated. This was partly because of the elevated status of the man in Chinese society, and because he needed more belongings with him when he left the house. At the same time, the fact that male attire was comparatively plain allowed the belt and its decorative hangings to become a focal point. As the Manchus became more settled and began to lead an increasingly sedentary life, the pouches they suspended from their belt became smaller and less constrained by functionality. As a result, the number and type of bags and pouches proliferated during the Qing Dynasty, although those most commonly used were pouches for money or tobacco, cases for fans and spectacles, and scented bags.

Although East Asian belt accessories originally derived from a common source, with many similar, shared features surviving into the late nineteenth century, the method used to suspend them in Japan from the late sixteenth century onwards was quite unlike those of other regions. In general, all pouches and containers used a single cord, although the position of the two cord ends in relation to the object they suspended differed in China and Japan. In China, the ends of the cord were attached to the top of the pouch, leaving the middle, upper part forming a loop through which the belt could be threaded. In Japan, the fact that the *inrō* and tobacco box had cord channels meant that the cord ends could be either at the top or bottom of the item (although they were invariably at the top). In addition, the continuous cord of Japanese examples was threaded twice through an *ojime*, so that it could be tightened round the suspended object. By contrast, similar beads on Chinese examples were threaded on a single cord, where they were purely decorative. Two cords, however, were used for Chinese draw-string purses, where the action of pulling the cords closed the purse tightly, thereby negating the need for an *ojime*-type bead. In addition to attaching the pouches by threading the belt through the loop, the highly regulated Chinese formal and semi-formal belts were fitted with ring-like appendages on the side of the body, following the earlier Mongol tradition. A number of items, usually paired on each side, was then attached to these rings.[11] In Japan, however, a novel method was devised for suspending objects that made it possible reach the contents of the pouches without undoing the sash. This involved passing the two cord ends of the pouch or container behind the sash. These were then attached to a netsuke, which hung over the sash and acted as a counterbalance to the suspended object.

Toggles[12] were the Chinese counterpart to the Japanese netsuke, although the earliest surviving examples do not appear to predate the Qing period. It has been suggested that they may have originated in Tibet or Mongolia and that the practice reached China with the Mongols during the Yuan Dynasty,[13] but there appears to be no evidence to corroborate this. Moreover, since toggles were seen as craft rather than art objects, they were not considered of sufficient importance to appear in written sources. At the same time, the small size of belt hangings and their position on the body means that they can very rarely be seen in contemporary pictorial records that could shed some light on the matter.

The majority of Chinese toggles were used as a decorative ornament on a cord, while others acted as a counterweight to the pouch to which they were attached, even though they were suspended from a cord loop.[14] It is a widely held view that the adoption of a toggle that acted in the same way as a netsuke occurred somewhat earlier in China than in Japan. I would suggest, however, that the reverse is true. Not only is there no evidence to support the hypothesis, but surviving examples are also later in date than the first true netsuke of the early seventeenth century. Although the use of a toggle-netsuke could have evolved separately in both China and Japan at much the same time, in view of their shared tradition of belt hangings, it was probably more than mere coincidence. Traditionally Japan has a long history of cultural borrowings from China, but there is no reason why in the case of an ingenious and highly effective practice, this could not have occurred the other way round.

The term 'netsuke' literally translates as 'root attach', suggesting that the first netsuke were natural, 'found' objects, such as a piece of root. Indeed, suitable natural objects were undoubtedly used to hang a pouch or natural gourd from the belt right across East Asia from an early date, although they were probably not used in the same way as subsequent netsuke. It is hardly surprising that such items were not treasured beyond their period of usefulness and, even if they were, it is doubtful that we would recognize them as netsuke. Throughout the Edo period (1615–1868) interesting stones, shells and wood with naturally worn holes, small gourds, nuts and bones, continued to be used as netsuke alongside specially created works.

Information regarding the earliest purpose-made netsuke is extremely scant. Since contemporary written sources on the subject are virtually non-existent, we have to rely on paintings, which are sufficiently plentiful in number and detail to make preliminary conclusions possible.[15] These suggest that, around the turn of the sixteenth century, accessories were tied to a comparatively large and thin ring, an *obiguruma* ('sash wheel'), usually of metal although also of ivory, through which the sash was threaded.[16] One cannot help drawing a parallel between this and the Mongol and Manchu custom of tying accessories to a ring or rings that were attached to the belt. It is also worth mentioning the strong resemblance of the *obiguruma* to the Hungarian *pásaztorkészség* ('shepherd's kit').[17] Since Hungarian shepherds traditionally wore clothing without pockets, they also tied the items they needed to a ring, with the leather belt threaded through. This grouping, known as *pásaztorkészség*, generally consisted of tobacco pouch, flint and tinder, steel for making sparks, knife, various tools and a spoon. Each object was suspended on a thin leather thong, together with a *kupáncs* or *boglár*, which resembled, and had a similar function to, an *ojime*. The *pásaztorkészség* has unmistakable connections with the Tang Chinese and Silla Korean belts with practical and decorative hangings. Indeed, strong similarities with other belts of Central and East Asia are revealed by a reconstruction of belt, pouch and hangings from archaeological findings of the Avar tribesmen of the eighth and ninth centuries in what is now Hungary, suggesting a common nomadic source.[18]

The relationship between the sash and netsuke during its formative period cannot be underestimated. During the late sixteenth and first half of the seventeenth centuries, for example, it became popular with both men and women to wear a narrow sash, known as a Nagoya *obi*. Reputed to have been inspired by the rope belt worn by Chinese crafts-

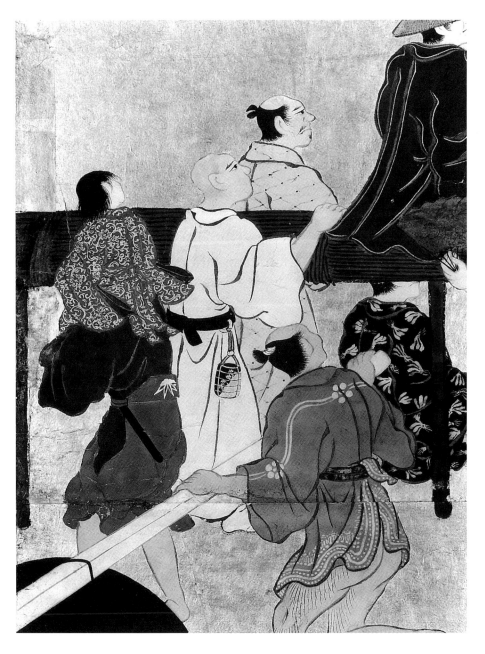

4 *Horse-racing at Kamo* (detail, from a pair of folding screens). The early netsuke consisted of a large, thin ring with a large opening, known as *obiguruma*, through which the sash was threaded. Ink and coloured pigments on paper. 1600–50. MOA Museum of Art.

men in the Nagoya region of Japan, it was composed of twisted silk cords that were wound around the waist.[19] This enabled either the cords that together formed the sash to be passed through the *obiguruma* or, alternatively, just a few of the lower cords, thereby securely suspending the *inrō* and pouch. A regular thin sash could equally be threaded through the ring. This is particularly well illustrated by the early seventeenth-century *Kamo keibazu byōbu* (folding screens of horse-racing at Kamo), in the MOA Art Museum, where 11 men are portrayed wearing an *inrō*, pouch, or both, all with thin sashes, and many with the Nagoya *obi* (Plate 4).

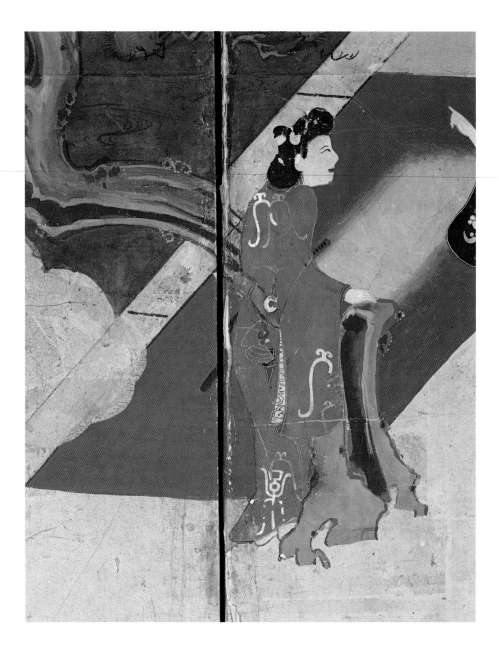

5 *Arriving by Boat at a House in a Pleasure Quarter* (detail, from a folding screen). The young man wears a seminal netsuke that consists of a thick, ivory ring with a small opening. The four cord ends appear to be passed up through the opening and tied in a bulky knot. Ink and coloured pigments on gold-leafed paper. 1630s.
ROM, inventory no. 989.24.46.

By the 1640s, two major changes appear to have taken place, however. These may be observed largely through the depiction of ten netsuke and *sagemono* in the *Yūrakuzu byō bu* (folding screens of illustrations of pleasure), in the Tokugawa Art Museum, also referred to as the Sōōji Screens owing to their connection with the Sōōji temple.[20] Since the screens are thought to predate 1643, it is possible to deduce that, by this date, the netsuke ring had become thicker with a narrower opening (a *kara* netsuke).[21] At the same time, the sash was no longer threaded through the ring but the netsuke, attached to the cords, first passed behind and then over a regular sash or, in the case of the Nagoya *obi*, through the cords making up the sash. Such a method had the distinct

advantage of allowing the pouch or container to be removed from the sash without it having to be untied and retied each time. This new accessibility is highlighted by the *Matsuura byōbu* (Matsuura screens) in the Yamato Bunkakan, wherein a man is portrayed freely holding in his hand an *inrō* and pouch tied to a ring of this type.[22] The *kara* netsuke may well be considered the earliest true netsuke, since the cords of the *sage-mono* passed behind the sash and the netsuke hung over it, rather than the sash passing through the netsuke as previously.

Over a period of time, the opening of the already thicker ring became even smaller and, instead of being tied to it, the two ends of the cords were passed through the opening. These were initially tied in a large knot to prevent them slipping back through the hole (Plate 5). Throughout the seventeenth century, moreover, it was common practice to hang the *inrō* and pouch from separate cords, but from one netsuke. This made it possible to tie a bulky knot that consisted of four cord ends instead of two. The bulky knot was then superseded by the practice of attaching the cords to some manner of 'plug', which was a more secure method of achieving the same end (Plate 6). Another type of 'plug' made use of a netsuke in the form of two concentric rings, one smaller than the other, with no visible sign of the cord on its uppermost surface. The cord ends were probably attached to the smaller ring, either on the underside or secreted somehow on the inside. There are even a few surviving netsuke of this type that quite possibly date

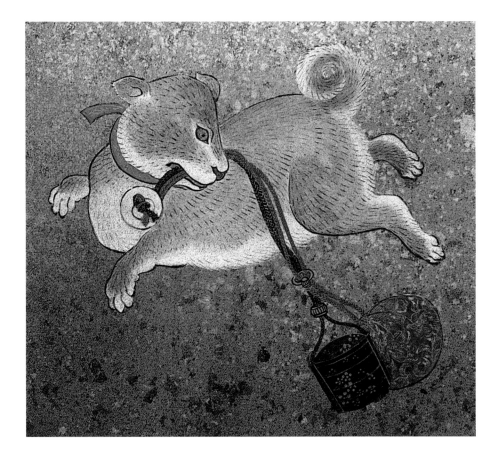

6 Dog with an *inrō* and pouch ensemble (detail, from a folding screen). This seminal netsuke consists of an outer ring and an inner disc. The latter is fitted with two holes to accommodate the *sagemono* cords, which are tied in a rough knot. The short-lived, early practice of passing a ring over the cords is also depicted. Ink and coloured pigments on gold-sprinkled paper. 1650s. Image supplied by Naga Antiques, Hudson, NY.

from the second half of the seventeenth century.[23] It is undoubtedly from such seminal forms that the fully developed *kagamibuta* and *manjū* netsuke subsequently evolved; these will be discussed in greater detail in the next chapter.

It is also worth mentioning that when an *inrō* and pouch were suspended together from the sash using only one netsuke, as was the common practice at this time, a number of sources also shows that a ring-like object was passed over the netsuke and down the cords (Plate 6).[24] In such cases, the ring slid down towards the item of *sagemono*, but was prevented from knocking and damaging it by the cords splaying out where they joined the container on its upper surface. Apart from being decorative, the ring drew the *inrō* and pouch together, so that they not only looked tidy, but were also stopped from banging into one another and the cords becoming tangled. It is possible that such rings were in fact former, recycled *obiguruma*. Several pictorial sources also suggest that, at around the same time, an alternative practice was to tie strips of fabric, usually red, around the cords of either the *inrō* or pouch (Plate 77).[25] This must have served a similar function, as well as being an aesthetic feature. The rings and fabric do not appear to have been used universally, however, and by the end of the seventeenth century the practices had largely become superfluous. This undoubtedly resulted from the increasing importance of the *inrō* and its subsequent separation from other items of *sagemono*, culminating in each item being suspended from its own netsuke.

From such diverse and scattered sources, it is impossible to propose an absolute sequence of development for early netsuke. Indeed, it is highly likely that there was no single course, and that the various forms co-existed over a period of time, with some being refined into types that we recognize today, while others fell from use. What does seem evident, however, is that by the second half of the seventeenth century, *netsukeshi* sought various means to hide the knot from immediate view. This was undoubtedly a prerequisite for the successful execution of surface decoration, showing a growing regard for the netsuke as an object in its own right and as a decorative medium. It is also worth noting that, after the first appearance of the *inrō* in its fully developed form during the second half of the sixteenth century, it achieved an enormous degree of popularity in a relatively short period of time. By the early seventeenth century, moreover, a large variety of different forms of *inrō* were already in existence. The rapid evolution of *inrō* types also suggests that a parallel development among netsuke probably took place. Indeed, by the second half of the seventeenth century, most of the main types of netsuke appear to have been in current use.

1 Lawton (1982), pp. 90–91

2 For an illustration, see Michaelson (1999), No. 42, p. 75.

3 White (1994), p. 22.

4 For illustrations see Shen (1981) pp. 254–57 and Wang (1986), p. 9, fig. 6.

5 Illustrated in Härtel (1982).

6 Belts of this type have been found in the south and north mound chambers of Hwangnam-dong Tomb No. 98, the Auspicious Phoenix Tomb, the Gold Crown Tomb, the Heavenly Horse Tomb and the Gold Bell Tomb, some of which are illustrated in Whitfield (1984), pls 79 and 92.

7 Illustrated in Hayashi (1975), pls 39 and 40.

8 Philippi (1968), pp. 238–240.

9 The practice of wearing a pouch and sword attached to the belt is illustrated by *haniwa* figures of the fifth to sixth centuries, see Liddell (1989), pls 9 and 12.

10 Unnumbered illustration in Arakawa (1983), p. 187.

11 For illustrations, see Medley (1957–9), pl. 45d, Garrett (1997), ch. 4, pl. 6, and Dickinson (1990), pls 138 and 139.

12 For three examples from the V&A's collection, see Kerr (1991), pl. 56

13 Cammann (1962), p. 18.

14 Garrett (1997), ch. 6, pl. 1.

15 For a full discussion of some of the most important pictorial sources, see Arakawa (1984), with many detailed illustrations pp. 8–9, Arakawa (1983), pp. 194–196, and Arakawa (1995), p. 49.

16 For one such possible example, see Kurstin (2002), fig. 2

17 Szeszler (1998), pp. 26–29.

18 Szeszler, (1988), fig. 6.

19 See Gluckman &Takeda (1992) p. 337.

20 Illustrated in Arakawa (1983) pl. 67, with some details in Arakawa (1983) p. 195 and Arakawa (1984) fig.1, all those marked no.10.

21 See Arakawa (1983), pp. 199–200.

22 Illustrated in Arakawa (1983) p. 194, top right.

23 Forrer (1999), pl. 3.

24 This practice can also be seen in two unpublished seventeenth century album leaves, 1978 7 24 05 Add. 579 in The British Museum, which are discussed at greater length on p. 74.

25 For another illustration see Earle (2001), detail of fig.1, p. 17, as well as an additional unpublished album leaf 1978 7 24 05 Add. 579, from the same source as Endnote 14 and plate 77.

3 Function and Forms of Netsuke

It is highly unlikely that netsuke would have developed if pouches and containers with specialized functions had not evolved during the second half of the sixteenth century. The *inrō* was the first such container to have made its appearance.[1] According to literary sources, the term '*inrō*' was used as early as the fourteenth century, originally referring to square or round tiered containers which were usually made in China of lacquer. By the second half of the sixteenth century, however, *inrō* had become much smaller and were adapted so that they could be suspended from the sash. In the form in which it is widely known today, the *inrō* is a small but distinctive container, usually of lacquer and comprising two or more stacking sections that fit tightly into one another. Although it was initially used to hold a man's seal and stamp pad or supply of medicines, it rapidly became a highly decorative and costly fashion accessory with little or no practical function. Once established in its fully developed form in Japan, the *inrō* became enormously popular in a short period of time.

If it was the rapid popularity of the *inrō* that proved to be the catalyst for the evolution of the netsuke, it was undoubtedly pipe-smoking that ultimately ensured its manufacture in large numbers. The Portuguese were the first Europeans to reach Japan in 1543, bringing the practice with them. They were followed shortly after by the Spanish, who had themselves introduced tobacco to Europe. Initially, tobacco had to be imported into Japan, making it an expensive, luxury product. At a time when new medicines and recipes from the West were being added to the traditional Chinese pharmacopoeia, smoking was readily adopted in Japan for its medicinal effects by those who could afford it. By the early seventeenth century, however, tobacco began to be cultivated in Japan, which not only lowered the price but also made it available to a wider section of the population. Smoking spread so rapidly that, by 1609, an edict was passed prohibiting the cultivation and smoking of tobacco. Despite severe penalties and the repeated renewal of such laws, smoking continued unabated. This culminated in the relaxation of the edicts in 1667 and, finally, their abolition in 1725.

Initially the Japanese smoked indoors, social etiquette requiring the host to provide a tray with tobacco and pipe for his guests. Gradually, as it became acceptable to smoke outdoors, wealthy people had their smoking paraphernalia carried by attendants. The communal pipe often became clogged, however, and so it became increasingly common for the individual to carry his own pipe, which he kept clean himself. It was kept either in his kimono or thrust into his sash, along with a supply of tobacco in a wallet or pouch, often in the folds of the kimono.

It is easy to imagine how a portable smoking set gradually evolved. Such sets consisted of a pouch or container filled with tobacco and tied to a pipe-case; this was thrust

Opposite: Detail from Plate 13.

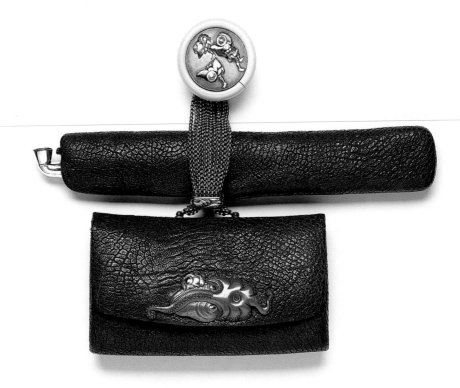

7 Smoking ensemble.
Tabakoire: Leather with clasp.
Copper octopus with patinated
eyes. Applied silver rat with
gold eyes and *shibuichi* patina.
Kagami netsuke with ivory
bowl: Figures performing the
sparrow dance. *Shibuichi* disc
with applied gold, silver and
brass. Silver pipe and chains.
1875–1900 D. 4.3cm.
W.134–1923. Hearn Gift.

through the sash, as illustrated by a number of pictorial records of the first half of the
seventeenth century.[2] One cannot help drawing a parallel between the development of
the portable smoking set and the earlier custom of carrying fire-making equipment in a
pouch. The very fact that the *inrō*, another item suspended from the sash, was achiev-
ing an enormous degree of popularity at around the same time, undoubtedly exerted an
influence over the developing portable smoking set.

The traditional Japanese pipe, the *kiseru*, is long and thin. It initially measured over a
metre long, but once it began to be carried about the person, it was reduced to a stan-
dard length of 20–30cm. It could be made from a variety of materials, although the main
segments, mouthpiece, neck and bowl were usually of metal, while the stem was of
bamboo or wood. As techniques for shredding tobacco gradually improved, it also
became possible to make the bowl smaller, the average bowl holding enough for two or
three puffs. Smoking practices in Japan involved far more than the act itself, for the
preparation and the cleaning afterwards formed an intrinsic part of 'having a break'
(*chotto ippuku*).[3] The pouch was removed from the sash, a few shreds of tobacco were
taken out, rolled into a ball and tamped into the bowl, and then lit from the brazier.
After a few puffs, the neck of the pipe was tapped against the rim of an ash receptacle
and the ashes emptied out. The smoker then blew forcibly down the mouthpiece to
remove any remnants of ash before putting the pipe away.

It was not until the first half of the eighteenth century, however, that personal and portable smoking sets came into widespread use. In particular, it was during the Kyōhō era (1716–36) that the *tabakoire* (tobacco pouch) came into being in the form in which it is generally known today. It was not only widely used by the working man, but also came to represent a symbol of status and wealth among the *chōnin*, especially merchants. The pouch was made from a variety of materials that were often decorated, including paper, cloth and different types of leather, the most treasured being imported luxury items to suit individual taste (Plate 7). The pouch was closed by a flap that was secured by a metal clasp (*kanagu*), while the top was fitted with two or three eyelets, through which a continuous cord was threaded. The cord ends then passed through an *ojime*, before being secured in a netsuke. Alternatively, they were attached to a pipe and pipe-case, which was thrust into the back of the man's sash, thus serving the same function as a regular netsuke. The tobacco pouch reached its height of popularity during the nineteenth century, when some of the finest examples were produced, many in the form of matching components. At the same time, it also became fashionable to substitute fine metal chains for the cord, to which the pipe and case were attached, necessitating the use of a large netsuke. After passing through the *ojime*, the individual chains were splayed out and attached to the top of the pouch.

Whereas the tobacco pouch was made from pliable material, the *tonkōtsu* (tobacco box) was rigid, and manufactured from a hard substance such as wood, although often decorated with a combination of other materials. Of the various possible components of a tobacco set, the *tonkōtsu* is probably the least studied. Although there are few early surviving examples, it seems likely that initially, at least, it was more widely used than the pouch or wallet. The production of both the tobacco pouch and *tonkōtsu* undoubtedly came into their own during the nineteenth century. The *tonkōtsu*, which was generally made in two sections – a container and lid – was supplied with cord channels, also requiring an *ojime* to help keep the parts together. The ends of the cord were then secured to a netsuke or pipe-case.

Netsuke Types

By the mid-seventeenth century, in a relatively short space of time since the use of *sagemono* had become commonplace, netsuke already appeared in a wide variety of forms, many of which subsequently became established types. *Katabori* ('shape carving') netsuke are not only the most well represented in Western collections, but also the most appreciated by collectors. As the term implies, *katabori* are carved in the round, and have a pair of holes or a natural opening through which the cord is attached (Plate 8). Recent evidence suggests that netsuke of this type date from at least the mid-seventeenth century, about 50 years earlier than was previously thought (see pages 74–5). It is also worth mentioning that miniature carvings fully in the round evolved in China during the Han Dynasty (206 BC–AD 221). Although these and subsequent carvings, especially those of the Song Dynasty (960–1279), are very similar in subject-matter to later Japanese *katabori* netsuke, there is no evidence whatsoever to suggest that they shared a similar function. It is possible, however, that Chinese animal carvings of this type may

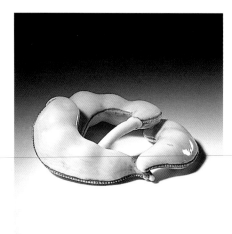

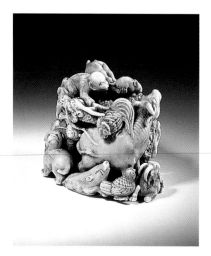

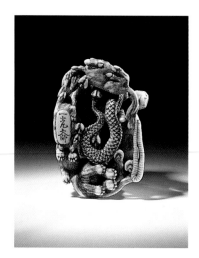

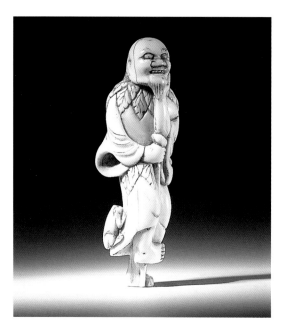

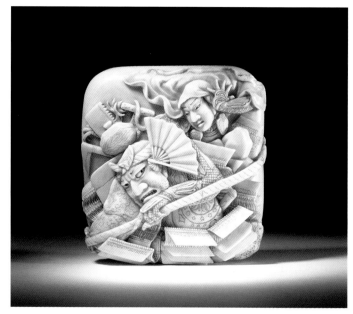

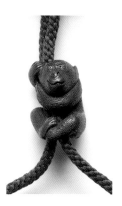

8 Beanpods. The stalk of the beanpods provides the means of attaching the *sagemono* cord. Ivory. 1775–1850. L. 4.6cm.
A.46-1920. Clarke-Thornhill Gift.

9 Animals of the zodiac. Ivory. Signed 'Ikkōsai'. 1825–75. H. 3.5cm.
A.920-1910. Salting Bequest.

10 Underside of Plate 9.

11 Gama Sennin standing on one leg, with a toad. Ivory. 18th century. H. 6.35cm.
A.11-1915. Fox Gift.

12 Monkey *ojime* (*left*). Copper with gold eyes. 1775–1875. H. 1.9cm.
A.59-1913.

13 *Manjū* netsuke (*above*). Yoshitsune and Benkei fighting on the Gojō Bridge. Ivory. Signed 'carved by Kōhōsai in Meiji 2 (1869)'. H. 5cm.
A.23–1963.

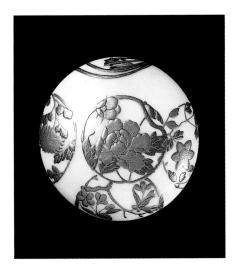 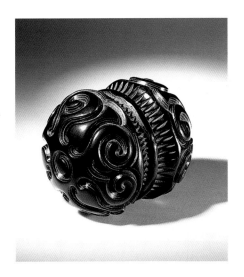

14 *Manjū* netsuke. Floral roundels. Ivory with gold *taka-makie* lacquer. Signed 'Moei', with a seal. 1775–1825. D. 4cm.
W.161–1922. Pfungst Gift.

15 *Manjū* netsuke in the form of a Japanese football. *Guri* lacquer with layers of black, red, green and yellow, carved with *rui* scrolls. 1775–1850. L. 3.8cm.
FE.18-1974. Garner Gift.

have influenced later Japanese netsuke. When worn hanging over the sash, *katabori* netsuke had a single orientation. Once removed from the sash, however, it could be turned over, fondled and appreciated to the full from any angle. Perhaps therein lies its greatest appeal, together with its minute attention to detail. This is particularly well illustrated, for example, by the depiction of the underside of an animal, complete with paws and genitalia, or even more so with a group of animals (Plates 9 and 10).

Although *katabori* netsuke are often regarded as miniature sculptures, it must be remembered that they could fulfil their primary function without necessarily being able to stand on a flat surface. Nevertheless, not only could they frequently do so, but they were sometimes also provided with an integral base. In fact, it became something of a *tour de force* among craftsmen to make a figure stand on one leg, even though it might seem top-heavy (Plate 11). It is also worth mentioning that when *ojime* are carved in the round, they share many characteristics with *katabori* netsuke, although they are much smaller, usually only having one central *himotōshi*. The most inventive or ingenious *ojime* play upon their purpose. One such example takes the form of a monkey that appears to climb up and down the doubled cord, while at the same time fulfilling its primary function (Plate 12).

The second most numerous type of netsuke is that known as *manjū*, so called after a type of rounded sweet dumpling filled with bean paste which it loosely resembles in shape. Since *manjū* netsuke may also be oval, square or a variety of related forms, the term came to be used in a generic sense (Plate 13). The inherent rounded, compact forms of the *manjū* netsuke, furthermore, made them intrinsically suitable for wearing next to the body.

There are many variations of the *manjū* type, even among the seminal netsuke of the seventeenth century. The most basic form is a single, solid piece of material that is flat, concave or convex, with a small metal ring fixed to the back for attaching the cord. A more complex variety of *manjū* consists of two pieces, generally in the form of hollowed-out halves (Plates 14 and 15). Netsuke of this type usually have a hole drilled in the middle of the back half, which allowed the two cord ends to be threaded through

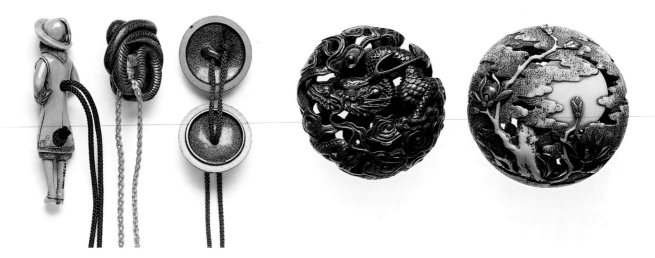

16 Netsuke showing different methods of attaching cords.

An ivory *katabori* netsuke with a pair of *himōtoshi* (see Plate 87). FE.284–1995. Schwaiger Bequest.

A wooden *katabori* netsuke of a snake, with the body forming a suitable point of attachment. L. 4.4cm. 947–1910. Salting Bequest.

The inside of a lacquered *manjū* netsuke, with a loop on the upper half and a hole in the lower. 1775–1850. D. 4cm. W.368:2-1922. Pfungst Gift.

17 *Ryūsa* netsuke. Dragon and clouds. Wood. Signed 'Toyomasa'. 1800–1875. D. 3.8cm. A.1025–1910. Salting Bequest.

Magnolia and moon. Ivory, with gold and silver. Signed 'Tōkoku'. 1850–1915. D. 4.2cm. W.247–1922. Pfungst Gift.

and attached to a ring or eyelet on the underside of the upper, front half (Plate 16). When an item of *sagemono* was suspended, the weight on the cord that was attached to the eyelet pulled both parts of the netsuke firmly together. The surface decoration of the *manjū* netsuke is equally varied; some are plain, while others have their entire exterior surface covered (although the side lying against the body was generally less elaborate, or plain).

A variation of the *manjū* is the *hako* ('box') netsuke. Netsuke of this type may be in the form of an imitation box, made from a solid piece of material, or may be boxes in the true sense, with two parts that separate (Plate 2). Depending on its size, the *hako* could have been used to store or carry small items. Another distinctive variety of *manjū* is the *ryūsa*, named after a craftsman from Edo who was known to have been active around the Tenmei era (1781–9), since he is mentioned in *Sōken kishō*. Netsuke of this type are usually made from a solid piece of material, which is hollowed out and decorated with deep carving in openwork (Plate 17). Although many have a ring for the cord attachment on the underside, the most intricate examples have the means to attach and secrete the cord by threading up through the inside of the netsuke, even though it does not open up. The *Sōken kishō* mentions that netsuke of this type do not damage the *inrō* to which they were attached. This was undoubtedly because, unlike *katabori* netsuke, their surface is relatively smooth.

The third main type of netsuke is traditionally referred to as *kagamibuta* ('mirror lid') in the West, although in Japan it is known as *kagami* (Plate 18); in this work, I shall follow the increasing trend to adopt the Japanese terminology. As the Western translation of the name suggests, this type of netsuke consists of two parts, a base, and a lid of metal resembling a traditional East Asian mirror. The circular bowl, which has an average diameter of 3–6cm, comprises a recessed continuous ledge just below the top interior. This allows the metal lid or disc, which is slightly smaller than the bowl in circumference, to sit flush with or slightly lower than the bowl rim. The remainder of the bowl, which is hollowed out, has a central hole bored in the bottom through which the cord

passes. The underside of the disc is fitted with an eyelet that corresponds with the hole in the centre of the base. Once again, when in use, the weight of the *sagemono* on the cord ensured that the disc rested tightly on the rim. In most cases the bowl is comparatively plain, relying for effect on the inherent beauty of the material from which it is made (often ivory). By contrast, the disc was the focal point of decoration; many leading metalworkers of the nineteenth century produced discs for *kagami* netsuke as part of their work.

Until comparatively recently, the *kagami* netsuke has been somewhat overlooked in favour of more popular types. It is partly for this reason, therefore, that the history of its evolution and development is insufficiently understood. It is widely agreed that the *kagami* netsuke in the form in which it is most commonly known today is a phenomenon of the nineteenth century, yet its close connection with *manjū* netsuke would suggest a much earlier date. It is highly likely that early forms of *kagami* netsuke were produced at various times, in different varieties and materials but without the metal disc, making a direct connection less obvious. In particular, a certain type of *ryūsa* netsuke is undoubtedly a form of *kagami* that predates the nineteenth century.[4] It is characterized by a small metal disc, prominently positioned in the centre of the uppermost surface, with a metal eyelet for the cord on the underside. The nineteenth-century 'reappearance' of the *kagami* netsuke in the form it is widely known today, therefore, was probably none other than the reinvention of a type that had already existed in different, but related forms. Moreover, at a time when the fashion-conscious *chōnin* were increasingly demanding new and interesting types of accessories, the *kagami* netsuke found widespread, popular appeal.

It has already been noted how the pipe-case could be worn thrust through the sash, attached to and suspending other tobacco accessories, so that there was no need for a netsuke. Using the same concept for suspending other *sagemono* was the *sashi* netsuke, a term that derives from the verb *sashi-komu* (to insert, thrust in). Long and thin, this type of netsuke was worn inserted up between the sash and the kimono, with the topmost, visible end its focal point of decoration. This part also had holes for the cord so that the *sagemono* hung down over the front of the sash. Related to the *sashi* netsuke is the comparatively rare *obihasami* ('sash claws'). This type comprises curved projections at one end of the netsuke that hook round the top of the sash, thereby securely anchoring it with the weight of the *sagemono*. The decoration of both the *sashi* and *obihasami* were often imaginative and inventive, bearing in mind that a large part of each was often covered by the sash. It is also interesting to note the close similarity in appearance between the *sashi* and *obihasami* netsuke and Chinese belt hooks (page 16); although they have completely different uses, they are nevertheless all connected with the belt or sash, deriving originally from a common tradition.

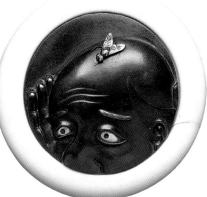

18 *Kagami* netsuke. Fly on a man's head. *Shibuichi* disc with applied silver and copper, and applied silver eyes with *shakudō* patina. Ivory bowl. 1850–1900. D. 4.4cm. M.1364–1926.

Dual-purpose Netsuke

Apart from the main types described above, there was a number of netsuke that served another purpose in addition to their main function. Since a high percentage of netsuke were used to suspend items connected with smoking, it is hardly surprising that several dual-purpose netsuke are also linked with this habit. In particular, the ashtray netsuke (Plate 19) consists of a simple metal bowl with a loop or ring on the underside for attaching the cord. The bowl is extremely small, but commensurate with a bowl of ashes from the Japanese pipe. Another smoking-related netsuke was the *hiuchi bako*, a mechanical flintlock tinder-box predominantly made of metal (Plate 20), which was undoubtedly related to the earlier *hiuchi bukuro* (pouch for fire-making equipment). It worked by pressing a small button on the outside of the compact box, activating a spring. This, in turn, caused a hammer to be released, which struck the flint, setting fire to inflammable material contained in a depression.

As well as the close connection with smoking accessories, many netsuke were used to suspend *inrō*. It is hardly surprising, therefore, that some netsuke developed dual roles associated with one of the original functions of *inrō*, that of holding the seal and stamp pad, as well as writing implements in general. Although the use of the seal in Japan was formally adopted under the Taihō Code of 701, under Chinese influence, it was not until the first half of the seventeenth century that the custom became widespread. Throughout East Asia, it was customary to append the impression of a seal to a document as a guarantee of the individual, his office or institution. The seal was generally made of a durable and, sometimes, costly material, including wood, bronze, ivory or semi-precious stone. The underside of the seal was carved in relief or intaglio with the characters making up the individual's name. In order to leave an impression, the seal was pressed on to a pad soaked in vermilion and stamped on to the document. A significant number of *inrō* of the seventeenth and early eighteenth centuries contains the remnants of cinnabar red or black for the impression of a seal in the larger, lower section, corroborating the fact that early *inrō* could be used as a container for seal and ink. In addition, the netsuke itself could be in the form of a seal, either of Chinese or Japanese manufacture. A seal, moreover, could be converted for use as a netsuke, either by the addition of cord holes, or by tying the cord to a suitable part of the carving. In such cases, the characters on the base were sometimes removed, just as a seal that changed hands might also have the characters obliterated. By contrast, netsuke made in the form of a seal, rather than for use as a seal, were frequently carved with the characters for 'long life' or 'good luck', while others were devoid of characters altogether (Plate 21). There is also an interesting type of seal that, although possibly of Chinese origin, is particularly relevant in the context of netsuke.[5] Examples are characteristically small (less than 4cm high), light, made of bronze, and with carved decoration on the upper part. Moreover, they all have the means of attaching a cord, most of these features being distinctive requirements of netsuke. Although its name, *itoin* ('thread seal'), suggests some connection with the silk trade, possibly as a seal for shipments of silk to which they were attached with a cord, this remains unproven. As the dating of such seals is also unclear, their connection with netsuke is, at present, speculative.

19 *Fireworks at Ryōgoku bridge* (bottom left sheet). A man seated on the canopy of a boat holds a pipe in one hand and, in the other, an ashtray netsuke attached to a tobacco pouch and pipe case. Utagawa Toyokuni. Woodblock print, double triptych. Mid-1820s. E.4900–1886.

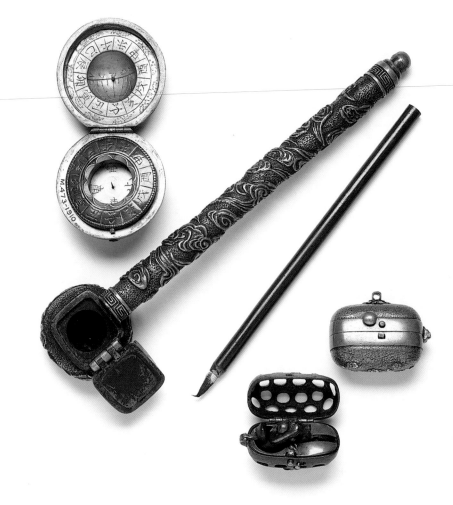

20 Compass and sundial: Dragon and clouds. Copper, steel and brass. D. 5.1cm.
M.473–1910.

Yatate: Stylized clouds and *hōo* birds. Brass, bamboo and animal hair. L. 19.9cm.
M.159–1928.

Hiuchi-bako netsuke: iron and brass. W. 4.2cm.
539–1908.

Brass, iron, silver and copper. W. 4.4cm.
M.554–1911.

All 1850–1900.

Yatate (Plate 20), miniature, portable writing sets, are another interesting case, as they can serve as both *sagemono* and netsuke. Although writing equipment had been carried in China from an early date, the practice only appears to date back to the early Edo period (1615–1868) in Japan. *Yatate* were not only used by literary figures, but also by men whose profession required them to write. They were made in a wide variety of forms, both with the brush and case separate from the inkpot, and with all three combined together. It was undoubtedly because function played such a vital role that surface decoration was frequently of secondary importance. This was often compensated for by the imaginative way in which the constituent parts were concealed. Whereas the brush holder may include bamboo and metal, the inkpot was invariably made of, or lined with, metal to accommodate the liquid ink. To help prevent spillage, absorbent

material, such as moxa or cotton, was also added to the inkpot. Depending on the form of the *yatate*, it could either be worn with the brush holder thrust through the sash in a manner similar to the pipe-case, or as a *sagemono* with an additional netsuke. Occasionally, the inkpot also served as a netsuke, so becoming another instance of a dual-function netsuke.

Yet other netsuke with secondary functions were those that incorporated a tiny telescope or folding knife. There is even a netsuke of spherical form that unfolds to reveal both a compass and sundial, marked with the animals of the zodiac to indicate time (Plate 20). Netsuke in the form of an abacus were especially useful for merchants and people handling money. Natural or imitation gourds of various sizes could also be used as either *sagemono* or netsuke. Such *sagemono* were invariably used by travellers to carry liquids; the netsuke were either appreciated for their inherent beauty or used as small containers with stoppers.

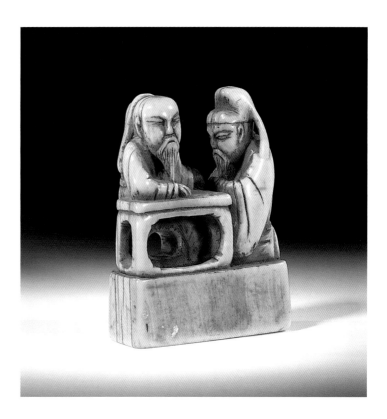

21 Seal netsuke with two Chinese scholars at a desk. Ivory. 1650–1750. H. 4.2cm. A.45-1930.

1 Since *inrō* have already been the subject of another title by the present author in the same series, it will not be covered here in any depth. The reader is referred instead to Hutt (1997).
2 For an illustration, see Meech (1995) Fig.1, bottom left. This is unusual in that it shows a pipe-case suspending an *inrō*.
3 Yoshio (2001), pp. 5–6.
4 Eijer (1994), p. 17.
5 Niiseki (1979), pp. 130–1.

4 | Materials, Techniques and Manufacture of Netsuke

Among the most striking features of netsuke are the richness and diversity of the materials from which they are made. It is probably no exaggeration to say that almost all materials known in Japan, both native and imported, were used at one time or another to make netsuke. By the nineteenth century, the *netsukeshi* had a wide range of materials at his disposal, selecting the most appropriate for a particular design or effect, and for the cost of the finished object.

Wooden Netsuke

Both wood (Plate 22) and ivory were traditionally the most widely used materials for the manufacture of netsuke, but wood was the most common up until the mid-nineteenth century. Since trees grow abundantly across the Japanese archipelago, wood was not only readily available, but many varieties could also be obtained at a reasonable price. Wood had been one of the main materials used in the manufacture of Buddhist sculpture since the seventh century, and so there was a long tradition of expertise in wood carving.

The classification of woods used for netsuke is often highly problematic. Wood is normally identified by the grain and ring pattern characteristic of each species, which can be seen in a cross-section of the trunk and branches.[1] The small size of the netsuke, however, usually makes this impossible. Whereas the natural colour of the wood may also help in identifying wood type, the surface of netsuke is often stained or painted. Two different varieties of wood that are frequently confused, for example, are ebony (*kokutan*) and black *umoregi*. The latter is often referred to as fossilized wood, although in reality it is jet, a type of lignite. It is for these reasons that, apart from a few obvious exceptions, catalogues or works on netsuke frequently fail to identify the specific material, using instead the generic term 'wood'.

Since Japanese cypress (*hinoki*) was widely used in the building of temples and shrines, it was an obvious choice of material for early wooden netsuke. Indeed, *hinoki* appears to have been favoured by Yoshimura Shūzan (d. 1773), one of the 54 *netsukeshi* mentioned in *Sōken kishō*. As it was a soft wood, however, its carved surface was easily worn down, so that some detail was lost. For this reason, it was not normally the first choice for netsuke carving, although such shortcomings could in part be overcome by painting or lacquering the surface after carving (Plate 93). Another soft wood, yew (*ichii*), is used particularly for its colour. The outer layer near the bark is creamy-white to yellow, whereas the centre is yellow to brown, with additional veining providing an

22 Kan'u, Chinese general and God of War. Wood. 1775–1825. H. 8.7cm.
A.13–1918. Wheatley Gift.

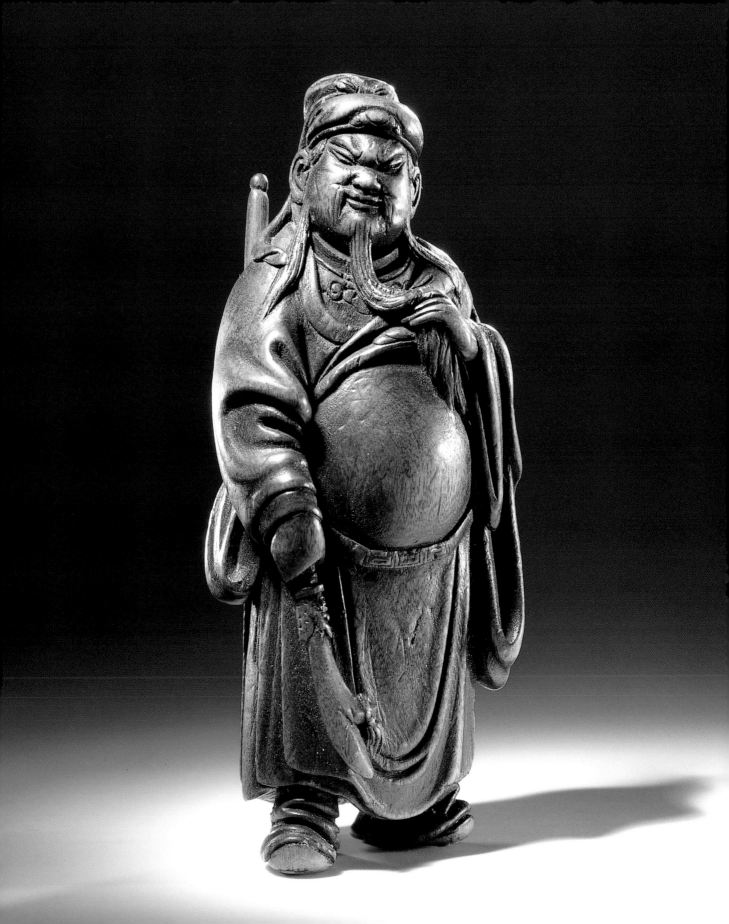

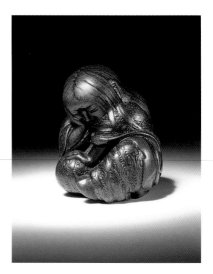

23 Mandarin duck. Yew carved in the *ittōbori* technique. Signed 'Sukenaga'. 1825–70. H. 3.5cm.
W.203–1922. Pfungst Gift.

24 Sleeping *shōjō*. Cherry wood. Signed 'Ikkan of Iwari province'. 1825–75. H. 3.5cm.
A.894–1910. Salting Bequest.

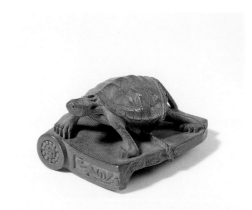

25 Tortoise tied to a roof tile. The pet tortoise is tied to the tile to stop it wandering off. Boxwood. Signed 'Chūichi'. 1900–25. L. 4.3cm.
A.38–1917. Florence Gift.

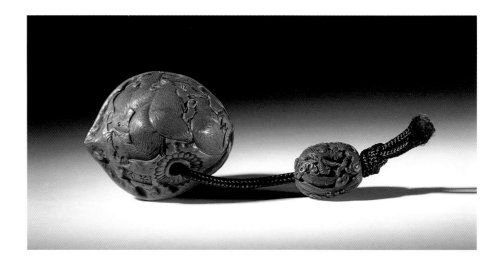

26 Netsuke: Rats. Walnut shell. Signed 'Kokusui'; *Ojime*: Dragon. Wood. Signed 'Kō zan'. 1800–65. L. 3.8cm.
A.50 &A–1920.

27 *Inrō* ensemble, cloth and peony. The netsuke is of a large piece of natural coral. The carp ascending a waterfall is a motif associated with the Danjūrō line of actors. *Surimono*: Signed 'Zekū', with the peony added by Gonjūrō. *c*. 1852.
E.4049–1916.

attractive contrast. Through careful planning, the *netsukeshi* frequently exploited the natural striation of the wood to enhance features of the netsuke, such as the crest or markings of a bird (Plate 23). In Hida province, yew was widely worked in the *ittōbori* technique (carving with a single knife-stroke), which became a speciality of the region (see page 96). Where local supplies of specific trees were plentiful, like yew in Hida province, such wood frequently formed the basis of regional netsuke production. This is also exemplified by the widespread use of cherry (*sakura*), a dark-reddish wood, by *netsukeshi* in the adjoining Nagoya and Gifu areas (Plate 24).

Of all the trees native to Japan, many are intrinsically unsuitable for netsuke carving, especially those that are soft or have a large grain. Since netsuke are small and subject to much handling, a durable wood with a fine, dense and even grain best lends itself to intricate carving. Boxwood (*tsuge*) is a material that most fulfils these criteria, and it was frequently used for netsuke (Plate 25). While it has a pale and creamy colour that acquires an attractive patina, it can also be polished to a high lustre. Among the many other woods used for netsuke are Japanese persimmon (*kurogaki*), camellia (*tsubaki*), jujube (*natsume*), isu (*Destylum racemosum*) and bamboo (*take*).

From an early date, it is evident that craftsmen sought new and interesting materials for netsuke. As early as 1682, for example, *Kōshoku ichidai otoku* ('The life of an amorous man'), a novel by Ihara Saikaku, recorded that a netsuke of rare imported wood was used to suspend an *inrō* and pouch.[2] Imported woods included ebony (Plate 106), fragrant sandalwood (*byakudan*), ironwood (*tagayasan*) and red sandalwood (*shitan*). Certain fruit stones and nuts, such as walnut shells, could also be used as netsuke (Plate 26). Although they are hard and difficult to work with, their surfaces could be intricately

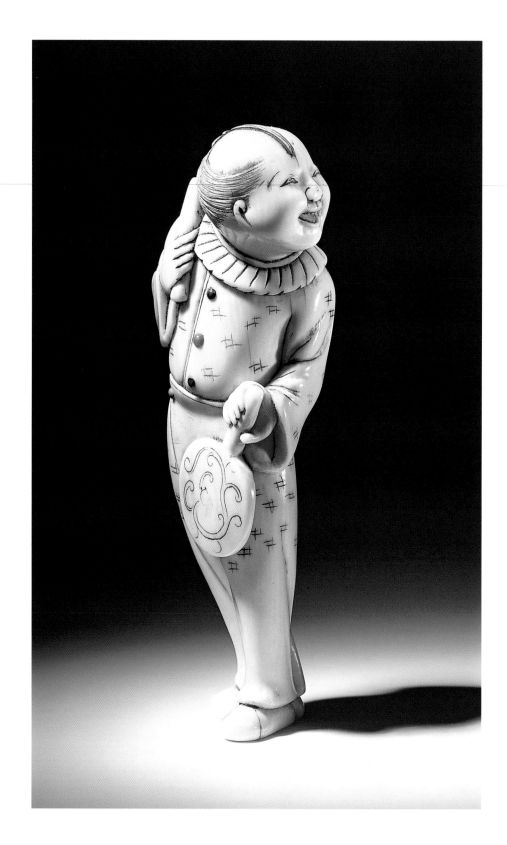

28 Figure in European dress.
Ivory with inlaid buttons.
18th century. H. 8.9cm.
A.862–1910. Salting Bequest.

incised or carved. Netsuke of this type are not only comparatively late in date, but surviving examples reveal that they are also prone to damage. Despite its name and wood-like appearance, *umimatsu* ('sea pine') is not a wood but a form of black coral, known in the West as litophyte.[3] Carved *umimatsu* netsuke were a special preserve of Iwami *netsukeshi*, in particular Kanman (1793–1859). Branches of regular coral were sometimes used as 'found' netsuke (Plate 27). The fact that they were somewhat heavy and likely to snag the kimono suggests that they were an exotic rarity. In particular, the actor Ichikawa Danjūrō VII (1791–1859) is said to have worn an *inrō* and a coral netsuke on stage; his flamboyant and costly dress was intended to endear him to the audience.[4]

Ivory Netsuke

Ivory constituted one of the most important and widely used materials for the manufacture of netsuke.[5] In its broadest sense, the term includes the tusks, teeth, bones and antlers of various animals, as well as vegetable ivory. True ivory, however, is the incisor teeth or tusks of elephants and mammoths of the proboscidean order. Since mammoths have been extinct for many thousands of years, carvers had to be content with the occasional chance find, particularly from Siberia. Although mammoth tusks could reach up to 5 metres in length, they are greatly curved and had often degraded. Elephant ivory derives from both the African elephant (*Loxodonta africana*) and the Indian elephant (*Elephas maximus*), with tusks from the male African elephant growing to the greater length. The animal was once native to parts of China, but although it has long been extinct there, it is still indigenous to many parts of South-East Asia. Throughout the Edo period (1615–1868), ivory from the Indian elephant was imported by Chinese and Dutch traders, with African ivory only reaching Japan in more recent times.

Elephant tusks are developed from a pair of incisors on the upper jaw that are continuously growing. The tusk is composed of two main parts, the root, which is embedded in the skull, and the visible part of the tusk. The root takes up about one third of the length of the tusk, and consists of a central core of soft pulp, which leaves a hollow cavity. A slice of tusk anywhere along this part may be used for rings or, where the cavity tapers, for *kagami* or *manjū* netsuke. The remainder of the tusk is solid, apart from a minute 'nerve' canal, which is rarely central and sometimes leaves a hole that needs to be plugged. The whole of the exterior is covered with an uneven enamel or rind. Tusks vary in length according to species and sex. Those of the African bull elephant measure 2–2.5 metres, while only the Indian bull grows tusks, which are around 1.5 metres (although some have none at all).

In cross-section, elephant and mammoth ivory are readily identifiable. The solid part of the tusk, or dentine, is made up of a vast number of tiny tubes that form two separate groups radiating out from the centre. One group radiates clockwise and the other anticlockwise, resulting in a distinctive pattern of lozenges where they intersect that is easily visible to the eye. The natural colour of ivory is creamy-white, and ivory from the Indian elephant is whiter than that from the African. Apart from the central core, ivory is even in colour and texture. Not only can the surface be polished, but it can also be painted or stained, while surface detail can be incised, carved or inlaid (Plate 28). As a

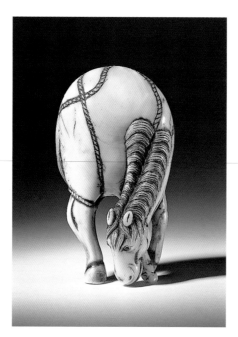
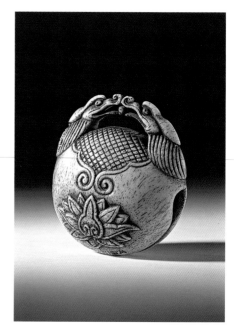

29 Horse. Ivory with inlaid eyes. 18th century. H. 5.6cm.
418–1904. Dresden Bequest.

31 Temple drum (*mokugyo*). Stag antler. Signed 'Koku'. 1825–1900. W. 3.5cm.
W.15:2–1922. Pfungst Gift.

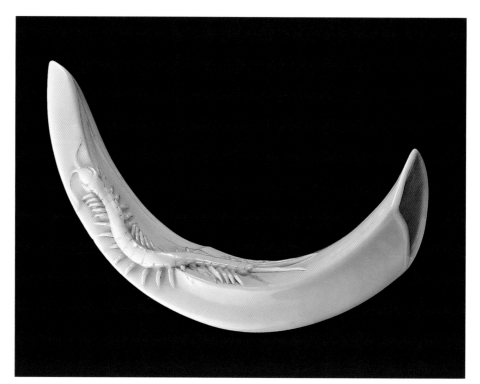

30 Centipede. Boar's tusk. Signed 'Iwami no kuni Enokawa Seiyōdō Bunshō chō koku (carved by Seiyōdō Bunshō by the Enokawa River in Iwami province). Early 19th century. L. 10.5cm.
FE.101–1996. Schwaiger Bequest.

general rule, ivory acquires a light- to deep-golden patina with age, handling, use, and exposure to light and certain environmental conditions. With the passage of time, however, the outer part of the tusk becomes darker than the inner core, which can result in a visible 'stripe'. Ivory has a hard (2–3 on the Mohs scale), dense body, which is strong yet pliable, lending itself to intricate carving. An illustration of an ivory and horn craftsman from *Jinrin kinmō zui* ('Illustrated instructions for proper behaviour'), published in 1690, is particularly instructive as to the methods of working with ivory.[6] It not only suggests that it was the craftsman himself who cut the tusk into sections and produced the different basic forms with a hand-turned lathe, but it also depicts a selection of the large variety of finished items he produced, such as combs, lids and *ojime*, as well as conveniently sized pieces of ivory for netsuke.

Although ivory was an imported, luxury material, it was intrinsically highly suitable for netsuke carving, and because of their size it was possible to use a small piece of ivory to maximum effect (Plate 29). Owing to the cost of the material, the ivory craftsman would have prevented wastage by using every piece he could, both for netsuke and other items. A tusk could be cut up in different ways, depending on the quality and purpose: the best parts for netsuke are the tip and adjoining section.[7] It is often possible to identify the part of the tusk from which a netsuke originated by its basic form.[8] In the case of figural netsuke, the coarser-grained outer part of the tusk, which was more likely to be discoloured through wear and exposure, was used for the back, which normally lay against the wearer's body. The front of the figure would then be formed from the lighter, more attractive part of the tusk.

Netsuke from tusks of the wild boar were a hallmark of carvers from the former Iwami province, where the boar roamed widely. Male boars have a set of four tusks, two small tusks in the lower jaw and two larger in the upper, which curve almost into a semi-circle. Whereas those of the female are small and solid, those of the male are hollow at the ends, to accommodate the root (Plate 30). Tusks from marine animals that inhabited the arctic regions, such as the walrus and narwhal, were also used as netsuke materials. As they are not from Japanese waters, they had to be imported, and were thus rare and expensive. The walrus grows large tusks of even texture and colour. Since it has a comparatively large crystalline core, however, *netsukeshi* often went to considerable lengths to disguise this. Narwhal ivory is derived from the upper left canine that forms a spiral tusk. It is roughly 6cm in diameter and the same length as the animal. In cross-section, the material consists of two parts: a rather white dentine of comparatively even texture, surrounded by a somewhat darker and irregular layer with radial cracks. These correspond to grooves on the outer surface that run along the length of the spiral tusk, which craftsmen often skilfully incorporated into the design of the netsuke.

Stag antler was widely used by *netsukeshi* working in Asakusa, Tokyo, during the late nineteenth and early twentieth centuries (Plates 31 and 99). It is the outgrowth from the frontal bones and, for this reason, shares many of the characteristics of bone. Male deer shed their antlers every year in early spring, followed by renewal. As growth progresses, a heavy deposit of bone develops at the base of the antler, known as the rose or burr, which cuts off the blood supply. The covering velvety skin dies and is then shed, exposing the new antlers. Stag antler is readily available and cheap, since it can be picked up by a hunter or found lying in the woods once shed. Nevertheless, it has its drawbacks.

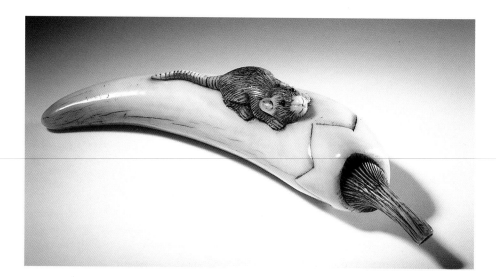

32 Rat on a capsicum.
Sperm whale tooth. 1750–1850.
L. 8.9cm.
811–1907. Pritchett Gift.

In particular, its shape is a limiting factor, as the curves, forks and tapering ends make it difficult to find a piece of sufficient bulk for carving. It also has a porous centre, which results in an irregular, spongy surface that may need to be plugged, while the material itself is very dense, and thus hard to carve. In the highly creative mind of Kokusai (?–1894) and some of his Asakusa followers, however, most of these inherent disadvantages were overcome by exploiting each to the full. Irregularities in the surface or shape frequently suggested a subject, so that they were then ingeniously incorporated into the design. In terms of shape, it is generally quite easy to identify the part of the antler from which the netsuke was made.[9] As well as compensating for the small size and circumference of the antler, forks in the material also produced some highly inventive compositions, such as netsuke in the *sashi* form, or a figure with outstretched or raised arms.[10] Similarly the rose or burr surrounded by hair readily lent itself to a head, complete with bristly 'hair'.

Along with tusks, the teeth of certain animals, such as the sperm whale, were suitable for netsuke. Sperm whale teeth are denser and harder than ivory (Plate 32). The interior is darker than the exterior, which is also quite thick, leaving less of the tooth for carving. Hippopotamus tooth has a thick, hard enamel coat; once this has been penetrated, however, it carves much like ivory. Occasionally the bones making up the paw of a small animal, or its jaw, complete with the teeth, could also be used as netsuke.

Vegetable ivory comprises nuts, usually from species of the palm, particularly *Phytelephas macrocarpa*, which grows in South America. It produces six or seven fruit, each containing up to nine nuts, each around 2.5cm long. When young, the nuts have a clear liquid inside the outer case, which turns milky in colour and hardens with age. It is this substance that can be cut to resemble ivory and is occasionally used for netsuke.

Synthetic ivories have been used as a cheap substitute for elephant ivory in the making of netsuke. Celluloid, for example, a transparent plastic made from camphor and cellulose nitrate, was available from around 1880 onwards. When tinted, celluloid resembles ivory, although it lacks the characteristic grain and is highly flammable. Since synthetic ivory netsuke were shaped in moulds, they invariably have an unattractive

'seam' running round the netsuke. While such netsuke have no artistic merit, their intention was undoubtedly to deceive the inexperienced collector.

Carving Methods

The techniques employed for carving a netsuke are broadly similar, regardless of the material. Thanks to a published discussion with the *netsukeshi* Masatoshi (1915–2001), we have a detailed record of the methods used by a renowned craftsman, along with his personal comments.[11] The basic tools employed by a *netsukeshi* fall into five main categories: saws, files, chisels, drills and knives. The tools were selected according to object, material and size. While he was working, Masatoshi had 224 tools to hand, of which he regularly used more than half.

After deciding on the subject, size and material, the *netsukeshi* cuts off a block of the material with a saw; a rough outline of the netsuke is then drawn on to it.[12] Any corners or edges that are not needed are sawn off, and the block is carved into the outline, using files and chisels. The next step involves shaving and scraping with chisels and drills, reducing the form to a closer approximation of its final shape. Surface and relief patterns, such as the fur of an animal, are next incised using fine chisels, drills and needles. The netsuke surface is then polished using increasingly fine abrasives, ending with the bare hands. The purpose of polishing is to remove any marks left by tools and previous polishing, and to eliminate oils, make the surface smooth and bring out the natural lustre of the material. This is essential not only if the material alone provides the finished surface, but also if staining and colouring are to be added in the final stage.[13] In total a high-quality netsuke might take one to two months to carve. At any point, either a slip in carving or the uncovering of an inherent weakness or blemish in the material can wreck all the previous work. Occasionally, this can be remedied if the affected area coincides with a part of the design that is not a focal or crucial point, but in most cases the netsuke is ruined.

Metal Netsuke

Netsuke made entirely of metal were comparatively rare, because they were heavy, and could damage a lacquered *inrō* by an accidental knock. The use of metal tended to be restricted to netsuke for which it was most suited, such as ashtray netsuke. To minimize their weight, metal netsuke could be hollow or decorated in openwork.

The most common use of metal in netsuke manufacture, however, was for the disc of a *kagami* netsuke. Originally the discs were probably made of iron, although at the height of their production they were made in a broad range of metals, including bronze, brass and copper, as well as various alloys.[14] Japanese metalworkers made widespread use of three copper alloys, *shakudō*, *shibuichi* and *sentoku*, the first two of which were also immersed in acid baths and heated, resulting in patinas of a wide range of colours. By far the largest number of discs are made of *shibuichi* ('one part in four'), referring to the rough proportion of copper to silver that it contains. Although this typically produced

33 Emma-ō, the King of Hell, evoking a *bijin* (beautiful woman) in his mirror. *Kagami* netsuke with ivory bowl. Disc: *shibuichi* with applied and inlaid gold and silver, with *shakudō* and copper patina. Signed 'Ryūmin' with a *kaō*. Applied silver plate mirror with *katakiri* engraving, signed 'Tenmin' with a *kaō*. D. 5cm. 1850–1900. M.1372–1926.

Similar netsuke (*right*), unsigned. D. 4.72cm. 271-1912.

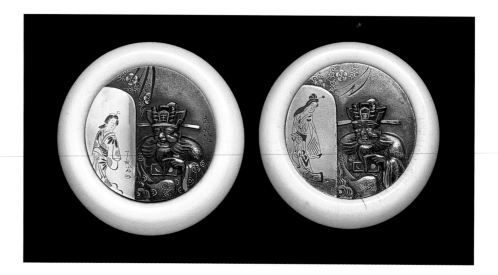

34 *Kagami* netsuke. Iron bowl with applied silver ants and gold inlay. Silver plate disc with web in *katakiri* engraving and applied *shibuichi* spider. Signed 'Toshimitsu'. D. 3.94cm. 1850–1900. M.1362–1900.

a silver-grey colour, it could vary from a light grey to a brown – the more silver, the lighter the colour. *Sentoku*, a variety of brass, is composed of copper, zinc, tin and lead, a mixture that results in a range of colours from light to golden yellow. The most spectacular colours, however – from blue, through purple to black – were the result of *shakudō*, which consisted of copper with a small amount of gold. In addition to copper alloys, those of gold and silver were also used, although these should be distinguished from sheets of cheap metals that were gilded or silvered.

As the focal point of *kagami* netsuke, discs were invariably highly decorated in a broad variety of techniques. The Japanese metalworker used a wide range of tools – predominantly chisels, hammers, punches and needles – both to form and to decorate an object. The decorative techniques were extensive, with many combined on a single netsuke. Those used for *kagami* discs included relief, inlaying and engraving. It is often necessary, where possible, to look at the reverse of a disc when trying to identify a particular technique. There were various methods used for producing relief effects, such as carving with a chisel and file. Levels varied from the highest carving to sunken relief, *shishiaibori* ('complexion carving', in which the highest parts of the design are level with the rim of the netsuke). The most basic inlay technique involved cutting away a shallow depression in the required shape, into which the inlay metal is fixed, usually by hammering. Although this resulted in a flat surface, *hirazōgan* ('flat inlay'), it could also be raised above the rim, a technique known as *takazōgan* ('high inlay').

Casting was similar to pressing, but was generally a cheaper and quicker method of producing a raised effect. A mould would only impart a rough form, needing more work before it could assume its final appearance. The relief areas of a disc, for example, could be further chased, resulting in additional relief, while other, specific parts of a design could be finished by inlaying or engraving. Although the metal employed for the base might vary, the use of a mould frequently resulted in the production of a large number of *kagami* discs of identical basic design. It was in the finishing details, however, that such examples could be given an individual appearance. There are, for instance, numerous *kagami* portraying Emma-ō, the King of Hell.[15] Whereas Emma-ō looks very

similar on all the discs, the chased or engraved lines of the curtains and arrangement of their decoration differ. In particular, the beautiful woman reflected in Emma-ō's mirror even receives varied treatment by the same metalworker, Tenmin (active second half of the nineteenth century) (Plate 33).

Metal netsuke discs made extensive use of two engraving techniques, *kebori* and *katakiribori*, the latter attributed to Yokoya Sōmin I (1670–1733). *Kebori* ('hairline engraving') utilizes a pointed, triangular chisel that leaves a V-shaped groove (Plate 34). By contrast, *katakiribori* ('shape-cut engraving') requires a chisel with a point formed by two lines of uneven length, resulting in a groove resembling a lop-sided V.[16] On the metal surface, this produces an effect similar to that of brushstrokes in painting, with a thick and thin cursive line.

Lacquered Netsuke

Since the majority of *inrō* were made of lacquer covering a core material, it is hardly surprising that lacquerwork is often encountered in the manufacture or decoration of netsuke, even though it is an expensive and time-consuming craft. Lacquer is the sap from the tree *Rhus verniciflua*, which grows throughout East Asia. After refining, lacquer can be coloured by the addition of vegetable and mineral dyes, which were traditionally restricted to black, brown, red, green and yellow. The unique physical and chemical properties of lacquer are such that in the presence of high humidity and temperature, the viscous liquid will solidify. Lacquer also has to be applied in extremely thin layers in order to harden, after which it is polished before the next layer is added. For a piece of high-quality lacquer, around 20 base layers are applied before the craftsman can embark upon the surface decoration. The finest achievements of Japanese lacquerwork are characterized by *makie* ('sprinkled picture'), a generic term for various related techniques (Plate 35). This involves building up a design by sprinkling metal or coloured powders on to a lacquer surface before it dries; once the design has hardened, it is then polished. The process is repeated until the desired depth or effect is achieved. As with metalwork techniques, lacquering revolves around the quest to portray different depths; the three fundamental *makie* techniques are *togidashie* ('brought out by polishing picture'), which is completely flush with the surface, *hiramakie* ('flat sprinkled picture') and *takamakie* ('high sprinkled picture').

Apart from *makie*, there are numerous other lacquer techniques widely associated with netsuke decoration. During the second half of the eighteenth and early nineteenth centuries, for example, it became popular to make *manjū* netsuke in

35 Toy dog. Black and red lacquer on a silver lacquer ground, with gold *togidashie* and *takamakie*. 1775–1850. H. 3.2cm.
W.258–1922. Pfungst Gift.

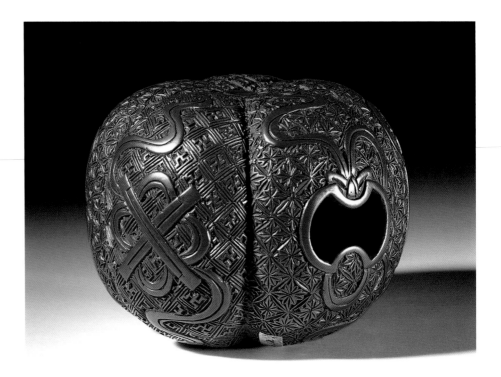

36 Auspicious objects (*takara-mono*) on a gourd. Carved red lacquer. 1775–1850. H. 3.4cm. Part of the stylized weights (*fundō*) are in openwork, thus providing one of the *himotōshi*. W.279A–1921. Sage Memorial Gift.

carved lacquer, a technique more closely associated with China (Plate 36).[17] For lacquer carving, it is necessary to build up the desired thickness by superimposing up to around 100 layers of lacquer for an *inrō* or netsuke. After transferring the design to the lacquer surface, the craftsman then carved the lacquer with chisels, knives and gouges, to produce designs of great intricacy and complexity, often on various levels. Another lacquer technique often associated with netsuke is Negoro-nuri ('Negoro lacquer'). This is a generic term for a style of decoration whereby red is applied over black lacquer. The surface is deliberately rubbed down so that the underlying colour shows through in irregular patches, providing an attractive contrast.

The emergence of a new generation of *netsukeshi* during the last quarter of the twentieth century, both in Japan and the West, heralded the appearance of some new materials, such as acrylic, together with a greater selection of woods from all over the world. In addition, changing attitudes to endangered species have resulted in the International Netsuke Carvers' Association deciding against the use of newly imported elephant ivory. In 1989, signatories of the Washington Convention prohibited all international trade in ivory and other materials from endangered species. This has resulted in *netsukeshi* turning instead to alternative sources of ivory, such as fossil ivory and rhinoceros horn.

Since 2001, the manufacture of netsuke has taken a new direction with the appearance of mass-produced examples at a very reasonable price. Born out of the collaboration of two companies, one producing toys and models and the other confectionery, they are

sold in packs with one netsuke to two sweets. Using moulds made from carvings of the highest quality, the netsuke are of resin that either resembles wood in colour or is coloured on the surface. Each example bears the necessary *himotōshi* of a true netsuke, while it also comes complete with a cord for attachment. Serving a purely decorative purpose, such netsuke may be attached to mobile phones, key rings or to bags, especially school bags, placed on computers or desks as ornaments, or simply collected. The netsuke are produced in limited series over a given period; whereas the previous group portrayed supernatural beings, the current set represents *fukujin* (gods of good fortune). Since the netsuke are sold in sealed packs, the purchaser has no idea which god he or she is buying, a clever marketing ploy which helps fuel the demand for such collectibles. At a time when little was known about netsuke by the Japanese, the enormous popularity of such netsuke has helped raise public awareness of the subject, especially among young people.

1 Photographs showing an extensive range of the grain of wood types used for netsuke can be found in Ducros (1987), pp. 29–32 and Ducros (1989), pp. 38–41, which is an adaptation and translation of the former.

2 Arakawa (1983), p. 196.

3 This information is based on Michael Birch's definition of *umimatsu* in the glossary of Lazarnick (1982).

4 Meech (1995), p. 17, quoting from Keyes and Mizushima (1973), p. 38.

5 Photographs of a range of the different types of ivory can be found in Ducros (1987), pp. 27–9 and Ducros (1989), pp. 36–7.

6 Arakawa (1983), p. 198 and Jirka-Schmitz (2000), fig. 2.

7 For a diagram of how a tusk is normally cut, see Masatoshi (1981), diagram A.

8 Hopkins (1982), figs 6, 7 and 8, demonstrates how various pieces of ivory (blocks and cylinders) could be cut up for use.

9 Hopkins (1982) 2, fig. 2, shows how an antler could be cut into manageable sections.

10 See Birch (1979) for drawings of some netsuke superimposed on an antler, showing how they were derived, exploiting the natural forms of the antler.

11 See Masatoshi (1981).

12 For photographs showing 20 stages of carving an ivory tiger, see Masatoshi (1981), pp. 44–5.

13 For details of the materials and methods used by Masatoshi for colouring and staining, see Masatoshi (1981), pp. 52–7.

14 For a full discussion of Japanese metals and metalwork techniques in the context of netsuke, see Eijer (1994), chap. 5, Materials and chap. 6, Techniques.

15 For some examples, see Eijer (1994), p. 35, pls 35–7.

16 For a diagram of the chisels used in *kebori* and *katakiribori*, together with the type of line they produce, see Eijer (1994), pl. 56.

17 For two examples of netsuke, see Hutt (1997), pl. 25.

5 Netsuke Subjects and Design Sources

The greatest appeal of netsuke undoubtedly lies in their subject-matter, in conjunction with the suitability of the materials chosen for them. Netsuke portray an extremely wide range of subjects, reflecting not only the real or imaginary world, but also the many facets of daily life in Japan. Rather than discussing the myriad subjects of netsuke in detail, however, I have instead presented these in broad categories and discussed their salient features, with particular reference to items in the collection of the V&A.

The main inspiration for netsuke subjects was undoubtedly the natural world, most frequently animals, birds, sea creatures (Plate 37) and insects, both real and imaginary, and of course, people. These were depicted in numerous compositional groupings, individually, as pairs, mother and young or as a larger assemblage, either on their own or with some reference to their natural habitat or the human world. Certain combinations often reflect conventions of Japanese art, such as the tiger and bamboo (Plate 38), which feature particularly in paintings from the late sixteenth century onwards. Coinciding with the increasingly realistic portrayal of netsuke subjects that began in the mid-eighteenth century, an interest in surface texture became apparent, such as the fur of an animal or the plumage of a bird. This was also seen in the deliberate depiction of different, highly textured surfaces, such as the unlikely combination of a toad on a straw

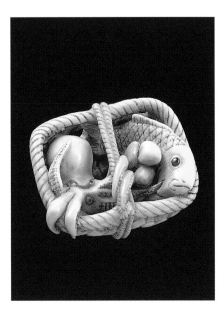

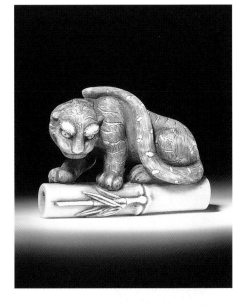

37 Basket with fish and squid. Ivory. 1750–1850. L. 4.5cm. A.59–1952. Shipman Bequest.

38 Tiger on a bamboo stem. Ivory. 1775–1825. L. 4.5cm. 428–1904. Dresden Bequest.

Opposite: Detail from Plate 64.

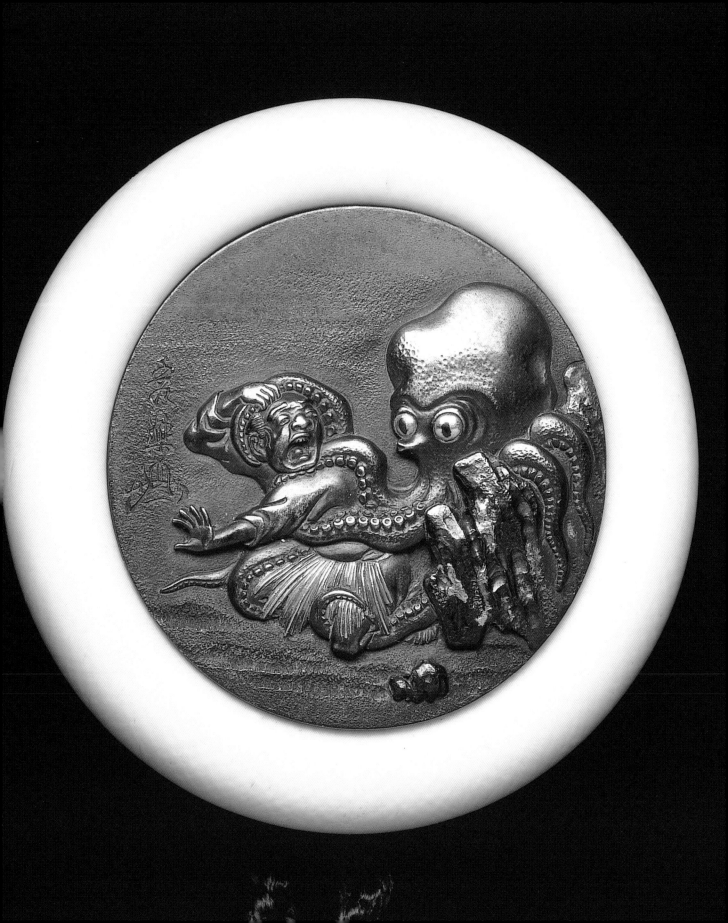

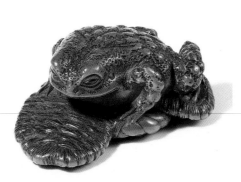

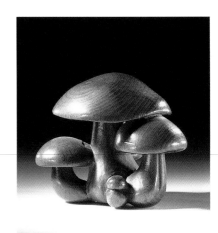

39 Toad on a sandal. Wood. Signed 'Masanao'. 1850–1900. L. 5.3cm.
A.53–1919. Clarke-Thornhill Gift.

40 Mushrooms (*honshimeji* [*lyophyllum shimeji*]). Wood. 1750–1850. H. 3.2cm.
A.55–1918. Wheatley Gift.

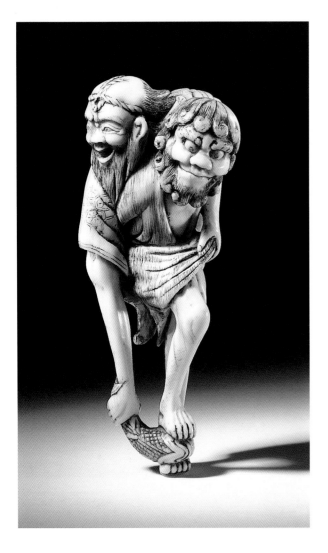

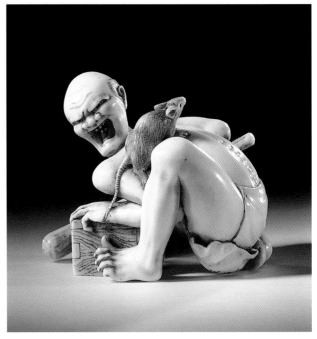

41 *Ashinaga* and *tenaga*. Ivory. 18th century. H. 7.3cm.
A.897–1910. Salting Bequest.

42 The thwarted rat catcher. Ivory. Signed ?'Masanari' or ?'Seikei'. 19th century. H. 3.9cm.
529–1904. Dresden Bequest.

sandal (Plate 39). Equally taxing to the *netsukeshi* was the contrast between smooth and highly textured surfaces. This is well exemplified by a group of mushrooms, with their smooth upper surface juxtaposed with the intricate pattern of the gills underneath (Plate 40). Other examples seem to have no surface texture, yet such deceptively simple netsuke actually required enormous skill to make them appear realistic. This may well account for the popularity of such subjects as a cluster of smooth gingko nuts or bean pods (Plate 8).

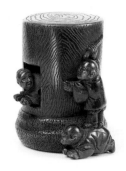

People, whether real, mythical or historical, provided a rich source of inspiration for *netsukeshi*. The distinctive imaginary pair Ashinaga ('long legs') and Tenaga ('long arms'), for example, was frequently depicted (Plate 41). Ashinaga, wading into deep water with his long legs, and Tenaga, fishing from his back with his long arms, represent the benefits of mutual assistance. Since the Edo period saw the rise of a thriving urban culture centred on Edo, Kyoto and Osaka, scenes connected with city life were of widespread appeal. It was, moreover, the *chōnin* who bought netsuke and *sagemono* in the greatest numbers. Trades and occupations, such as the mirror polisher, blind masseur and rat catcher (Plate 42), and people going about their daily life, form an important category of netsuke subjects.

The sense of place and theme of travel are deeply rooted in Japanese art. Despite the fact that people were not free to move around during the early part of the Edo period, the government built up an efficient network of roads and waterways that were fundamental to its political and economic hegemony. The only legitimate reason for travel open to the mass of the population was to make pilgrimages to sacred temples and shrines. Although ostensibly for religious purposes, many people also used these journeys as an opportunity for additional sightseeing. As restrictions were eased during the 1820s, nationwide travel for business or pleasure became common. This is reflected in the subject-matter of certain netsuke, such as the enormous pillar at the Great Buddha Hall (Daibutsuden)

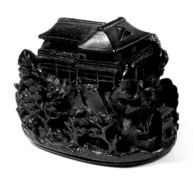

of the Tōdaiji temple, Nara. Well known to tourists, this column has a square hole cut right through near the base, allowing slim and agile visitors to climb through. According to popular belief, crawling through the opening was thought to bring religious merit. It is easy to imagine how someone who had just completed a trip or pilgrimage to Tōdaiji might well have bought a netsuke with this subject. An example in the V&A has even been made more true to life by the addition of trick mechanism whereby a woman can be made to move backwards and forwards through the hole as though crawling through it (Plate 43).

Netsuke in the form of landscape are comparatively rare (Plate 44). This is not only for obvious reasons of size but also because, in order to appear realistic, such netsuke generally require a large base. Netsuke of this type, moreover, do not lie comfortably against the body while the cord channels, often on the underside, appear almost superfluous. An interesting variation of the landscape theme is represented by a netsuke in

43 Pillar in the Daibutsuden (Great Buddha Hall), Tōdaiji temple, Nara, with pilgrims. A woman is climbing through the hole. Wood. Signed 'Hidetama'. 1800–50. H. 3.4cm. A.853–1910. Salting Bequest.

44 A house perched on a rocky landscape. Ebony. 19th century. H. 3.8cm. A.13–1915. Fox Gift.

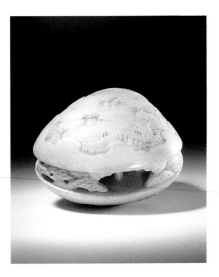

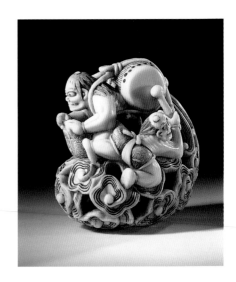

45 Three famous views of
Japan on a clam shell. Ivory.
Signed 'Issai Fujiwara
Masahiro'. 1775–1825.
H. 2.9cm.
442–1904. Dresden Bequest.

46 Daruma doll. Wood.
Signed 'Sukenaga'. 1825–75.
H. 4.1cm.
A.23–1919. Clarke-Thornhill Gift.

47 Raijin and Fujin (Gods of
Wind and Thunder). Stained
ivory. Signed 'Shōgetsu' with
a *kaō*. 1800–50. H. 4.29cm.
A.741–1910. Salting Bequest.

the form of a clam shell, decorated with three famous views of Japan (Plate 45). Whereas
Matsushima and Ama no Hashidate were depicted in low relief on the shell's exterior
surface, Miyajima temple was carved in openwork and relief inside the shell, itself a
considerable achievement.

Netsuke that portray religious subjects in the broadest sense are surprisingly numer-
ous, undoubtedly as a result of the secularization of religion during the Edo period.
Reference was rarely made overtly to key Buddhist figures, but rather to peripheral
subjects, such as the Indian priest Bodhidharma (Jap: Bodai Daruma or Daruma), the
founder of Zen Buddhism. In his quest for religious enlightenment, he is believed to
have meditated in a cave for nine years, during which his arms and legs atrophied. It is
for this reason that he is frequently depicted as a rounded amalgam of head and body
without any limbs (Plate 46). He became popularized in this form during the Edo period
as a roly-poly toy that rights itself when knocked down. Daruma also acquired humor-
ous, even irreverent, connotations. Since '*daruma*' was a term for a courtesan in the
jargon of the pleasure quarters, the two were often portrayed walking together in a sug-
gestive manner.[1] Gods and other revered figures who had entered popular mythology
were widely depicted, such as the Gods of Wind and Thunder (Fujin and Raijin) (Plate
47), as well as the Seven Gods of Good Fortune (*Shichifukujin*), who are often portrayed
individually (Plate 93).

During the Edo period theatre was important, whether it was classical Nō drama,
Kabuki (the popular urban theatre) or Bunraku (puppet theatre). While stylized music
and dance, termed 'Gagaku' and 'Bugaku' respectively, were performed in court circles,
popular dances took place the length and breadth of the country, often in connection
with festivals. With the exception of Kabuki, masks were a common feature of many of
these performances, whether spoken or dance. Netsuke alluding to the performing arts
often take the form of an actor, dancer or a mask. Masks worn by the principal actors of
the Nō theatre appear in their most developed form, representing every conceivable
emotion of man, woman, animal and supernatural being at different stages of their life
(Plate 48). The identification of mask netsuke is often complex, since many are not

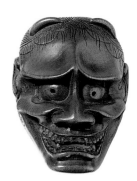

immediately recognizable out of context. There are, however, some notable exceptions, such as Okame. As a mask netsuke, she is invariably portrayed with a kind and laughing countenance composed of a rounded triangular face, deep-set eyes and eyebrows painted high on the forehead, although she often appears in figural form as well (Plate 50). Mask netsuke also occur in groups of twos, threes or more (Plate 63). There are even hidden-mask netsuke that are cleverly devised to be seen equally from two viewpoints with different designs so that, by turning them through 180°, the top becomes the bottom and the bottom the top.

The choice of netsuke subject, whether suggested by the material or commissioned by a client, was often connected with a specific season or festival. One of the most important of these was undoubtedly New Year. The Japanese traditionally divided their year according to the lunar calendar, with the new year falling between late January and early February. In 1872, however, under Western influence, the solar calendar was adopted so that today Japanese New Year corresponds with that of the West. The East-Asian zodiac, which derives from Chinese cosmology, makes use of twelve zodiac animals or *jūnishi* ('twelve branches'): the rat, ox, tiger, hare, dragon, snake, horse, goat, monkey, cock, dog and boar, in their traditional order. These were not only used to indicate years, but also days, hours, seasons and directions. In combination with the *jikkan* ('ten stems'), moreover, they formed a repeating cycle of 60 years that was the main method of calculating a date. It was not uncommon to find netsuke depicting all twelve animals, although this was a challenge to the craftsman's compositional and carving skills (Plates 9 and 10). It was undoubtedly the *jūnishi* system that provided the main impetus for the production of animals from around the mid-eighteenth century onwards, with some being more popular than others, especially the rat, monkey and tiger (Plates 3 and 49). It was most fitting, therefore, for a man to use the appropriate zodiac animal netsuke over the new-year festivities, or even to commission a new one, which could then be matched up with an *inrō* of similar subject. Such a netsuke could also be used at any time throughout the year, as well as being re-used in 12 years' time in accordance with the cycle.

48 Masks. Wood, 1800–75 (*left to right*):

Jō. Signed 'Sessai'. H. 4.6cm. A.65–1918.

Jō. Signed *'tenkaichi* Deme Uman'. H.4.7cm. A.63–1918.

Hannya. Signed 'Deme'. H. 5.7cm, W. 3.6cm. A.1009–1910. Salting Bequest.

Hannya. Signed 'Deme Uman'. H. 4.4cm. A.61–1918.

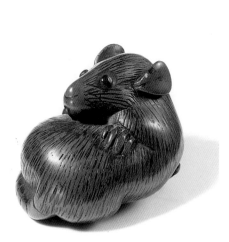

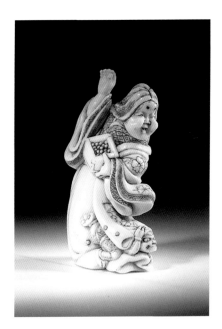

49 Rat. Wood with inlaid eyes. 1750–1800. L. 4.6cm.
A.958-1910. Salting Bequest.

50 Okame scattering dried beans, with an *oni* hiding under her kimono. Ivory. 1775–1850. H. 5.3cm.
A.743–1910. Salting Bequest.

There were also other customs and festivities associated with the new year that were widely reflected in netsuke. On the last day of the year, a rite known as *oniyarai* (demon expelling) is traditionally observed to drive out demons associated with diseases and calamities of the previous year (Plate 50). The ritual involves scattering special beans around the house while chanting '*oni wa soto fuku wa uchi*' ('out with the bad, in with the good'). An additional New Year celebration is that of *shishimai* ('*shishi* dance'), whereby an individual or group masquerades as a *shishi* formed by a mask with a cloth body. The *shishi* then dances in a synchronized sequence of stooping and crouching, while also twisting and turning. Yet another dance particularly associated with New Year is performed by a *sanbasō* dancer. The dancer, frequently portrayed as a netsuke, wears a distinctive, elongated hat with twelve horizontal stripes, representing the months of the year, while he also jangles a stick of bells.

The depiction of subject-matter

The enormous appeal of netsuke subject-matter lies not only in the wide range of motifs, but also in the interesting and inventive manner in which they are portrayed. Rather than rendering them as static compositions, a conscious effort was often made to imbue netsuke subjects with an underlying sense of motion. Similar to the effect of an action photograph, some netsuke even go so far as to depict a moment of dynamic movement that is encapsulated within an inanimate object, such as the wild boar in full gallop (Plate 71). This particular netsuke is all the more remarkable when one considers that it is portrayed in isolation of any ground, yet is sufficiently powerful to render any context superfluous. It is also interesting to note the parallel between Japanese and Western artists in their misconception of the way four-legged animals ran with all their

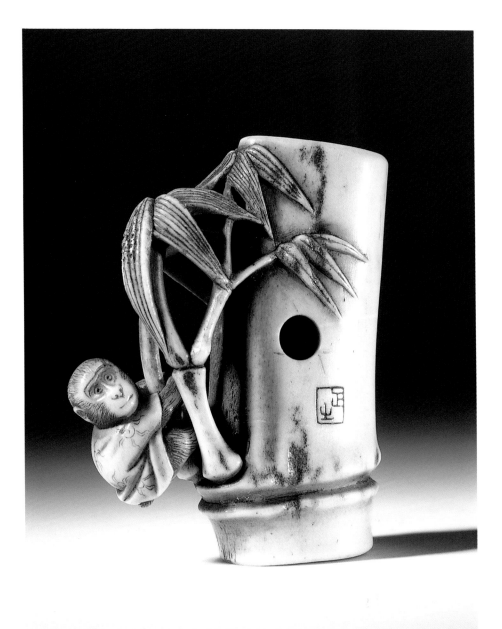

51 Monkey climbing a bamboo
shoot. Stag antler. Signed
'Masayuki'. 1850–1900.
H.4.5cm.
445–1904. Dresden Bequest.

limbs outstretched. As Gombrich pointed out in 1950, it was only when photography
had been perfected towards the end of the nineteenth century that the true mechanics of
animal movement were captured.[2] In extreme examples, the movement of a small part
of a netsuke in relation to its other parts was actually achieved, rather than simply being
depicted. This was most commonly in the form of a freely moving ball in the mouth of
a lion, carved from a single piece of ivory (Plate 80). A further example from the V&A's
collection portrays a monkey clinging to an offshoot of a bamboo stem, in such a way
that it can move up and down (Plate 51).

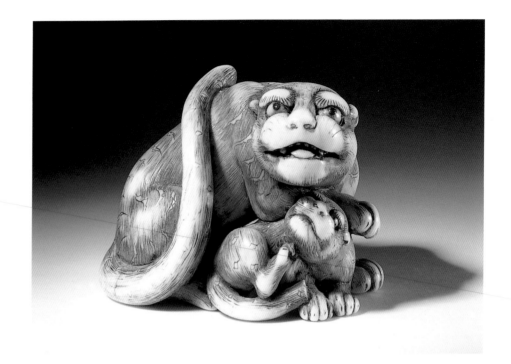

52 Tiger and young. Ivory
with inlaid eyes. Signed
'Tomotada'. 1775–1825.
H. 3.6cm.
A.49–1915. Dresden Bequest.

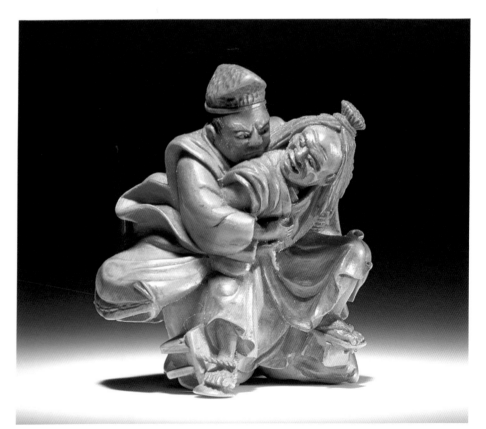

53 Taira no Tadamori
mistakenly attacking the
oil thief. Wood. 1800–50.
H. 4.5cm.
A.804–1910. Salting Bequest.

 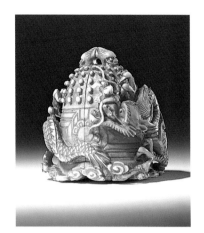 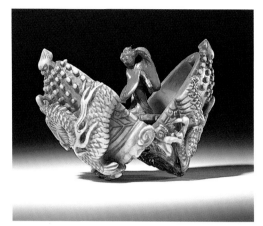

Another, subtler concept of movement is frequently conveyed in netsuke decoration. This relies on first grasping one's attention and then devising the means to lead one's gaze all around the netsuke and back to the starting point. This may be achieved in a variety of different ways, one of the simplest using the device of a long and sinuous tail (of a tiger, for example), twisting round the animal's body (Plate 52). Other netsuke use carefully planned components to draw the eye first in one direction, usually to the extremities, before another element takes over, diverting attention to another part. In this way, the unwitting viewer is lured into scrutinizing the netsuke from all angles. This is often exemplified by an animal's head leading in one direction, counterbalanced by its tail drawing off in another. The interaction between two or more people engaged in a fight was yet another method used to convey dramatic movement. By careful positioning of the head, limbs and clothing, for example, the netsuke of Taira no Tadamori mistakenly attacking the oil thief successfully conveys the impression of both action and force (Plate 53).

As *inrō* and netsuke rapidly grew in popularity from around the mid-eighteenth century onwards, becoming items of high fashion, they also underwent a fundamental change in the nature of their decoration, and their clientele sought examples of an increasingly interesting and inventive nature. One method of achieving this was to expand the small and restricted size of the netsuke by incorporating unlikely, unusual or hidden elements as an integral part of the overall composition, at the same time often exploiting the unexpected. This is well illustrated by the netsuke of *oniyarai* at New Year, with Okame throwing beans from a container while, unknown to her, an *oni* can be seen hiding under the skirt of her kimono, taking cover from the beans (Plate 50).

The story of *Dōjōji* ('The Dōjō Temple'), with its interpretation of vengeful, female jealousy, presents *netsukeshi* with unique possibilities for hidden and surprise elements. The story in its various versions stems from a tenth-century legend, which subsequently formed the basis of Nō and Kabuki plays. According to the story, Kiyohime, the beautiful young daughter of an innkeeper, fell in love with a priest, Anchin, who scorned her persistent advances. Furious, she was transformed first into a witch, then a dragon. When Anchin took refuge underneath the great bronze bell of the temple, she used her magical powers to force the bell to crash to the ground, trapping Anchin inside.

54 Dōjōji temple bell, with a dragon, skull and bones on the interior. Lacquer imitating bronze; coloured lacquer *togidashie* and *takamakie* inside. Signed 'Unryūan'. Dated 1998. H. 4.1cm.
FE.63-2002.

55 Dragon coiled round the Dōjōji bell. Ivory, the dragon with inlaid eyes. Signed 'Kagetoshi'. 1850–1900. H. 3.4cm.
A.813–1910. Salting Bequest.

56 The witch Kiyohime dancing inside the Dōjōji bell. See Plate 55.

Thereupon, she coiled herself round the bell, creating an intense heat that burnt Anchin to death. In the collection of the V&A is a contemporary netsuke in the form of a bell, made from lacquer imitating patinated bronze (Plate 54). A detailed inspection also reveals a dragon coiled round the inside, together with a skull and bones – an extremely skilful achievement. Yet another netsuke in the V&A uses hidden elements to tell the tale. Once again, the netsuke portrays a bell around which a dragon is coiled (Plate 55), but by means of a trick mechanism, the bell opens up to reveal Kiyohime dancing inside (Plate 56). Such workmanship is typical of netsuke of the second half of the nineteenth century. A further example of a netsuke with concealed decoration takes the form of an octopus trap, textured to imitate the surface of the ceramic barnacle-encrusted original. On close examination, however, it is found to conceal an octopus already caught inside (Plate 95). Although the netsuke typifies the innovation sought by *chōnin*, the fact that

57 Monkey and a double-gourd; the interior with monkeys attached to a chain. Ivory. This is all the more remarkable, considering it is carved from a solid piece of ivory. 1850–1900. H. 5.4cm. A.926–1910. Salting Bequest.

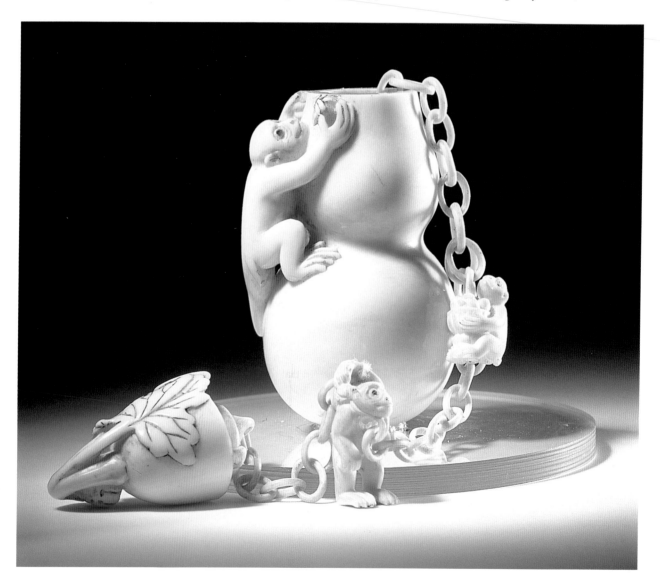

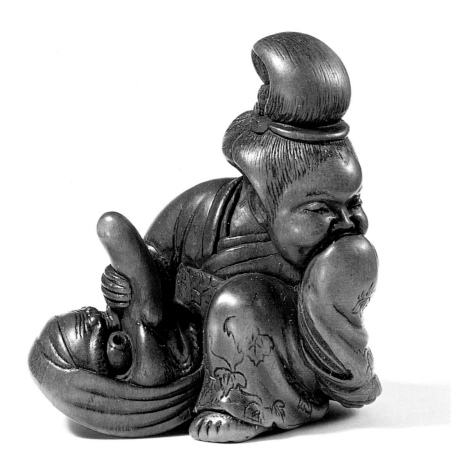

58 Okame with a long-nosed, phallic mask. Wood. 1775–1850. H.4.4cm.
A.744–1910. Salting Bequest.

the outside of the trap is inscribed with a haiku by the famous poet Matsuo Bashō (1644–94) suggests that it was also made to appeal to a client well versed in poetry.[3]

Many nineteenth-century *netsukeshi* were unashamed in their quest for both novelty and technical excellence, often at the expense of practicality. Plate 57 is a typical example, composed of two small monkeys clinging to a chain and lid that all fit back inside the gourd. Indeed, the use of an interlinking chain carved from a solid piece of ivory is more typical of Chinese, rather than Japanese, workmanship. Although it has a place for attaching a cord, it was probably not intended as a functioning netsuke and is likely to have been made in China.

An important underlying facet of netsuke subject-matter that customers found enormously appealing was humour or playfulness (*asobi*), whether overt or subtle. It is easy to imagine, for example, how a netsuke depicting a woman coyly, yet knowingly, smiling while holding the long, phallic nose of a mask, would be of universal appeal to men brought up in the context of the Yoshiwara pleasure quarters (Plate 58). A different type of humour is typified by the close-up of a man's face on a *kagami* disc, which shows the consternation caused by a fly that has settled on his forehead (Plate 18).

Design Sources

The *Sōken kishō*, the only book published during the Edo period that deals directly with netsuke, illustrates some of the more exceptional pieces known at the time. It is hardly surprising, therefore, that it became widely used as a design source for contemporary and later craftsmen – there are many versions of the netsuke illustrated known to be in existence. One such example in the V&A (Plate 59) is a close variation of the drawing of a monkey netsuke on a base (Plate 60), probably carved shortly after the first appearance of the *Sōken kishō*.

 In recent years, considerable research has been carried out on the use of woodblock-printed books as source material for *inrō* and, to a lesser extent, netsuke. The makers of both *inrō* and netsuke were essentially craftsmen rather than artists, who were not always able to provide an endless source of original and innovative designs for their work. Instead they turned to printed books which, from the seventeenth century

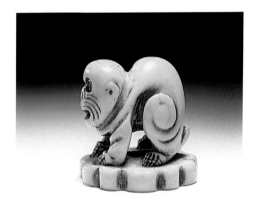

59 Monkey on a base. Ivory. 1775–1825. H.3.5cm.
A.48-1915. Fox Gift.

60 Miscellaneous Chinese carvings.
Sōken kishō ('Strange and wonderful sword fittings'), compiled by Inaba Tsūryū Shin'emon. Woodblock-printed book, Vol. 7, first published 1781.
Far Eastern Section Library, V&A, R 3G 12.

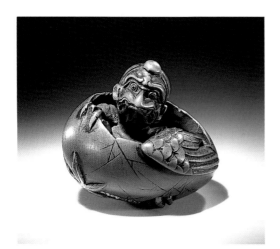

onwards, began to circulate widely in Japan at affordable prices. Such books vary from literary to pictorial works with little or no text, illustrating a vast range of subjects from the natural world and everyday life, as well as myths and legends. Together they provided a wealth of visual information well beyond the knowledge and experience of the average craftsman, such as flora and fauna that were not indigenous to Japan.

Among the few woodblock-printed books that were produced specifically for craftsmen, there do not appear to be any solely intended for the manufacture of netsuke. There were, however, a number that were obviously meant for *netsukeshi* among other craftsmen. One such example, *Chō kō hinagata* ('Models for carvers'), published in 1827, is a slim volume. Although it was aimed at wood-carvers in general, and included models for temple and domestic buildings, the preface specifically mentions netsuke, while at least two pages illustrate animals and figures suitable for netsuke. The fact that these are on bases and drawn in an altogether different style suggests that they could be of wide general appeal. As models for netsuke, the bases could either be omitted altogether or, in the case of seal-type netsuke, included.[4] Yet another title, *Banshoku zukō* ('Designs for all craftsmen'), a series of five volumes published between 1827 and 1850, was illustrated by Genryūsai Taito, a follower of Katsushika Hokusai (1760–1849). Volume 3, dated 1830, includes a number of illustrations of animals and plants that lend themselves particularly to netsuke, while several are contained within a circle, suggesting their immediate suitability for the disc of *kagami* or *manjū* netsuke. The illustration of a *tengu* hatching from an egg (Plate 62) is a subject frequently found among netsuke (Plate 61). Isai, yet another pupil of Hokusai, produced several books that were

61 *Tengu* hatching from an egg. Wood. Signed 'Shūmin'. 1800–75. H. 3.8cm.
A.907–1910. Salting Bequest.

62 *Tengu* hatching from an egg and other designs. *Banshoku zukō* ('Designs for all craftsmen'), illustrated by Genryūsai Taito. Woodblock-printed book, Vol. 3, published 1830.
E.14838-1886.

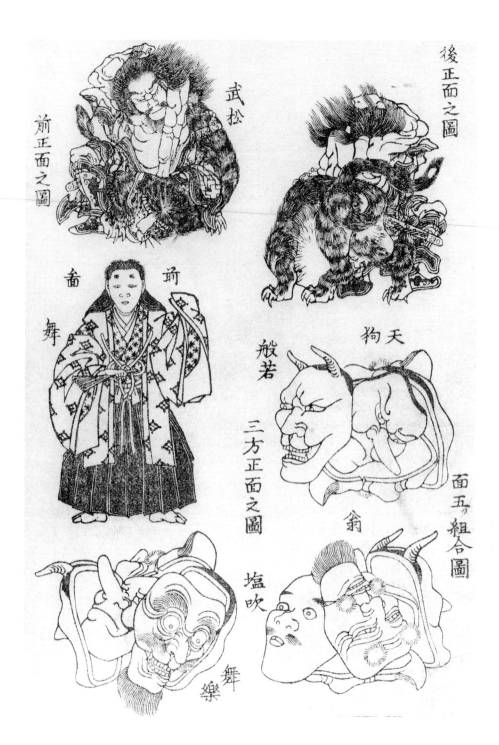

63 Drawings of netsuke, including one with composite masks from three angles. *Isai Gashiki banbutsu zukai* ('Isai's drawing method for many things'), illustrated by Isai. Woodblock printed book, published *c*. 1850.
E.7001-1916.

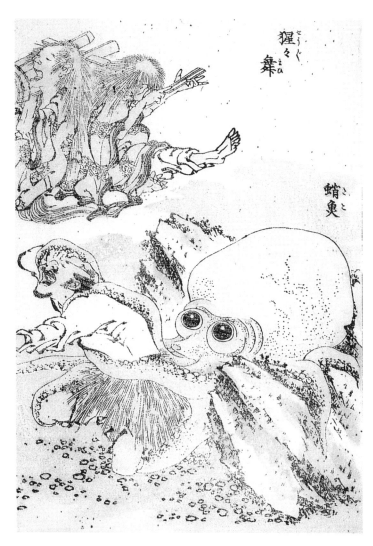

admirably suited to the requirements of *net-sukeshi. Isai gashiki banbutsu zukai* ('Isai's drawing method for many things'), published around 1850, presents detailed drawings of possible subjects, including some within circles. Although several examples show the same subject from various angles, suggesting that the drawings were from actual netsuke, the title of the book implies that its main purpose was instructional (Plate 63).

In view of the dearth of illustrated books aimed specifically at *netsukeshi*, it is hardly surprising that they made widespread use of works of a more general nature as source material. Indeed, among the vast corpus of books published during the Edo period, most of the leading titles or series included illustrations that could be copied directly or adapted as netsuke. In particular the flat page of a book frequently lent itself directly to the two-dimensional decoration of the *kagami* or *manjū* netsuke, with little adaptation being necessary. *Manga* ('Random sketches'), an extensive work by Hokusai published in 15 volumes between 1814 and 1878, provided endless inspiration for numerous craftsmen. This is exemplified by a page from Volume 15, which depicts a terrified man caught unawares in the tentacles of an octopus, much to the amusement of two onlookers (Plate 65). The disc of a *kagami* netsuke reveals that it is a close copy of the main part of this image (Plate 64). Yet another example from the same work is more complex in its transmission from one medium to another. A double-page spread from Volume 3 of *Manga*, first published in 1815, depicts numerous figures performing the sparrow dance, each in a different pose.[5] The disc of a *kagami* netsuke (Plate 7), meanwhile, portrays three of these dramatic figures, selected from both pages. Since there are far too many figures to be

64 *Kagami* netsuke. Octopus ensnaring a man in its tentacles. *Shibuichi* disc with *shakudō* patina and applied gold. Signed 'Shūraku' with a *kaō*. 19th century. 1850–1900. D. 4.2cm.
M.1387–1926.

65 Octopus ensnaring a man in its tentacles. *Manga* ('Random sketches'), illustrated by Katsushika Hokusai. Woodblock-printed book, Vol. 3, published 1815.
Kress Archives.

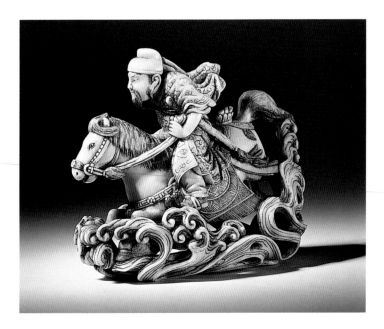

66 The Chinese General
Gentoku. Ivory. Signed
'Rakueisai'. 1850–1900.
L. 6.4cm.
A.781-1910. Salting Bequest.

67 The Chinese General
Gentoku. *Ehon shahō bukuro*
('Bag of sketching treasures'),
illustrated by Tachibana
Morikuni. Woodblock-printed
book, Vol. 7, first published
1720.
Kress Archives.

depicted satisfactorily on one netsuke, the crafts-man has instead selected three which, when combined together, make a successful and uni-fied composition.

Whereas it is often easy to identify the source of a *kagami* netsuke with some degree of certain-ty, that of a *katabori* netsuke is a more complex matter. Can one say, for example, that a netsuke of a dog in an everyday pose was not the result of direct observation from nature but instead came from a design in a book, no matter how similar it looks? Generally one needs more com-pelling evidence, such as details of dress, the turn of a hand or an unusual or distinctive stance. One such convincing example is a *katabori* netsuke of the Chinese general, Gentoku, escap-ing across a river (Plate 66), which bears a strik-ing similarity to an illustration from *Ehon shahō bukuro* ('Bag of sketching treasures'), illustrated by Tachibana Morikuni and first published in 1720 (Plate 67). Admittedly there are some differ-ences, notably the right hand holding the whip lies along the horse's rump on the netsuke, whereas it is held up and streaming behind in the book, while the horse's tail is also flattened down behind on the netsuke. These, however, are all perfectly acceptable modifications dictated by the need for compactness.

Although books were by far the most widely used two-dimensional source for providing designs, *ukiyoe* prints are also known to have been adapted to netsuke formats. To copy a print successfully, complete with background details that were frequently an essential part of the com-position, a *kagami* or *manjū* netsuke was ideal. A print by Utagawa Kunisada (1786–1864) illustrating a scene from the *Shiranui monogatari* ('The tale of the white embroiderer'),[6] was evidently the design source for a *manjū* netsuke in the V&A (Plate 68). The *Shiranui monogatari*, a novel and Kabuki play of the late Edo period, concerns the revenge of Princess Wakana of the Ōtomo clan against the brave and loyal Toriyama Shūsaku of the Kikuchi clan. The print depicts the confrontation between the two, with the former obtaining magical powers from the spider spirit. Owing to the overall com-plexity of the design, the *netsukeshi* has rendered only the right-hand half of the original composition, showing the princess seated on an enormous spider. He has further adapt-ed the design by omitting the background of waves, substituting instead a ground of a massive web that partially continues over to the reverse.

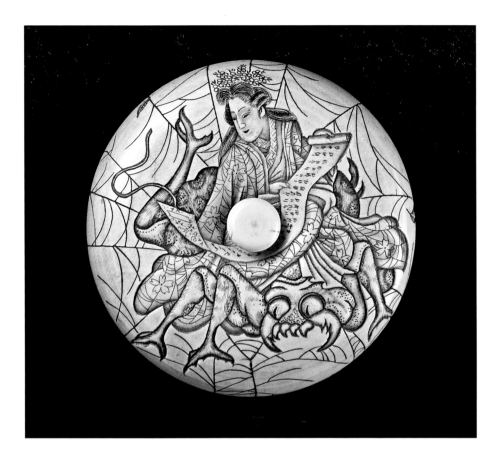

68 *Manjū* netsuke. Princess
Wakana, a spider and its web.
Ivory. Signed 'Reigyoku'.
1850–1900. D. 8cm.
564–1904. Dresden Bequest.

A cursory examination of surviving netsuke highlights the fact that many netsuke depict almost identical compositions, down to the most minute detail, often in different materials and surface treatment. This may have been the result of two different factors, or a combination of both. Firstly, duplication of designs often resulted from using the same pictorial sources from woodblock-printed books, prints or, more rarely, paintings.[7] Secondly, it became common practice to copy an earlier netsuke, which then became established as an iconographic type that was passed down by practical demonstration from one *netsukeshi* to another. This was often realized through master-pupil transmission within a netsuke workshop, frequently with compositional variations creeping in. A combination of factors is exemplified by the large number of almost identical netsuke of a boar sleeping by a small rock with grasses, in different materials and at different times (Plate 69). They have a possible design source in Volume 9 of *Ehon shahō bukuro*, allowing for certain modifications in its transmutation from a detailed drawing to a practical netsuke (Plate 70). Yet the fact that they are invariably depicted on a bed of maple leaves clearly delineated on the underside of the netsuke, something not shown in the printed version, suggests that the original was a netsuke that was subsequently handed down and copied, rather than a pictorial source. It even seems likely that the printed form of the design may have been inspired by the popular netsuke version.

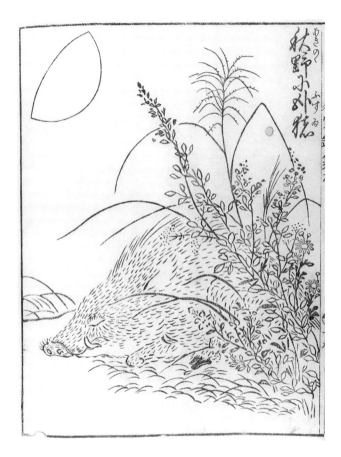

69 Boar sleeping by a stone: (*left*) Wood. Signed 'Ryōshi'. 1850–1900. L. 3.6cm.
A.943–1910. Salting Bequest.

(*right*) Ivory with coral dewdrops. Signed 'Masatsugu, one of the twelve zodiac signs'. 1850–1900. L. 5.2cm.
A.942–1910. Salting Bequest.

70 Boar sleeping by autumn plants. *Ehon shahō bukuro* ('Bag of sketching treasures'), illustrated by Tachibana Morikuni. Woodblock-printed book, Vol. 9, first published 1720.
E.14855-1886.

71 Wild boar. Wood, with eyes inlaid in horn. Signed 'Toyomasa', 1800–50. L.6.9cm.
A.53–1915. Fox Gift.

72 Wild boar. *Ehon shahō bukuro* ('Bag of sketching treasures'), illustrated by Tachibana Morikuni. Woodblock-printed book, Vol. 9, first published 1720.
E.14855-1886.

The complex relationship between woodblock-printed designs of different date and the netsuke themselves is further highlighted by a netsuke depicting a wild boar running at full gallop (Plate 71), which closely resembles a page from Volume 9a of the aforementioned *Ehon shahō bukuro* (Plate 72). Since most craftsmen had probably never seen a wild boar running, Toyomasa, the *netsukeshi* in question, might well have been inspired by the distinctive action-pose from this book. It is also interesting to note that an undated sketchbook by Kagetoshi (active early 19th century) contains 54 designs for netsuke, with two to a page, as well as two designs for small and two for large *manjū* netsuke, two designs for *okimono* and two for *inrō*. These appear to have been neither outline drawings serving as models, nor drawings from existing netsuke. Instead, they seem to have been idealized drawings of possible netsuke subjects, complete with detailed backgrounds that would have been impractical for functioning netsuke. Of these, one design portrays a running boar surrounded by flowers and plants (Plate 73), the essence of which is almost identical to the earlier *Ehon shahō bukuro* design, as well as Toyomasa's netsuke. Was Kagetoshi's drawing closely inspired by the design in *Ehon shahō bukuro* or by existing netsuke, such as Toyomasa's? And why would a *netsukeshi* of Kagetoshi's standing choose a design that had already been in existence for a long period rather than one of his own making? Whereas in some instances, it would seem likely that innovative designs were highly sought after, in others the reworking of traditional subjects and compositions were considered the height of netsuke practice.

73 Design for a netsuke: a wild boar running through flowers and plants. Album leaf, by Kagetoshi. Ink on paper.

1 Guth (1992), p. 51.

2 See Gombrich (1977), pp.10–11, pls 13–14.

3 The haiku reads: An octopus trap / Dreaming empty dreams / The summer moon! (*takotsubo ya / hakanaki yume o / natsu no tsuki*), see Earle (2001), p. 237.

4 Illustrated in Hillier (1979), fig. 8.

5 Illustrated in Hillier (1979) fig. 30, Michener (1974) pl. 33 or Hillier (1980), pl. 78.

6 For an illustration, see *Ukiyoe Encyclopedia* (1981), Vol. 4, fig. 230.

7 For an example, see Wrangham (1987), p. 11, figs 1 and 3.

6 | Aspects of Dating Netsuke and Chronological Groupings

Some of the greatest problems surrounding netsuke lie in their dating. In order to help establish a framework in which netsuke may be placed, it is not only necessary to examine the timescale of their production, but also to identify key datable groups and their chronology. There is, in addition, a relatively small percentage of netsuke that can be accurately dated, such as those that were excavated in recent years from tombs dating from the Edo period (1615–1868). The majority of these tombs, dating from the early nineteenth century, reveal little unexpected data. One exception, however, is a *manjū* netsuke excavated from the tomb of Makino Tadato of the Nagaoka clan, which provides most interesting information. Since the occupant of the tomb died in 1766, the netsuke must be of this date or earlier (Plate 74). Lacquered netsuke or *inrō* decorated in the *kimma*-style are of a type normally associated with the nineteenth century (Plate 75). A netsuke such as this, however, provides incontrovertible proof that such workmanship is much older than previously thought. It also supplies firm evidence that the *manjū* netsuke, which divides into two equal parts, was current as early as the 1760s.

Some netsuke are actually inscribed with a date, although these are not as common as one might think, mainly appearing in the nineteenth century and later; moreover, the authenticity of an inscription should always be questioned. A typical example is a *manjū* netsuke incised on the reverse with the craftsman's name, Kōhōsai, along with the date of manufacture, 1869, which seems totally consistent with the design and type of netsuke (Plate 13).

It is interesting that the earliest signed netsuke were probably made by craftsmen who worked in media and forms with traditions that predate netsuke manufacture, such as metalwork and lacquerwork. In particular, the lacquerer Ogawa Haritsu

74 *Manjū* netsuke, top (*left*) and bottom (*right*). *Hōo* birds and auspicious objects (*takaramono*) on scrolls. Red on black *kimma* lacquer. 1766 or earlier. D. 4.2cm. This netsuke was excavated from the tomb of Makino Tadato, of the Nagaoka clan, who died in 1766.

75 *Manjū* netsuke. Scrolls and geometric designs. Red and gold on black *kimma* lacquer. 1800–50. D. 4.1cm.
W.192A–1921. Sage Memorial Gift.

Opposite: Detail from Plate 79.

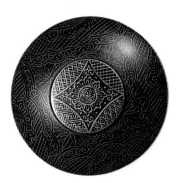

76 Rat on a piece of salmon. Wood, lacquer, mother-of-pearl shell and gold *takamakie* lacquer. Signed with the *Kan* seal of Ogawa Haritsu. 19th century. L. 3.1cm.
W.442A–1910. Salting Bequest.

(1663–1747) is probably one of the earliest craftsmen known to have signed netsuke, even allowing for the large number of later copies that were made. Since he was renowned for his simulation of other materials in the lacquer medium, some of his most characteristic netsuke were imitations of sticks or cakes of ink, usually in halves or three-quarters, as though partly used.[1] There is also a number of netsuke signed with the *Kan* seal of Haritsu in the form of whole or part of a fish, frequently with a piece cut off showing the flesh; the exposed section is often faced with mother-of-pearl shell (Plate 76).

As has already been discussed in the second chapter, the first true netsuke, which were natural objects such as shells and stones, could not have predated *inrō* and other *sage-mono*, while the earliest crafted netsuke seem to be early seventeenth-century. The *obig-uruma*, *kara* and other seminal netsuke for which we have no names were mostly short-lived, while more practical forms developed that subsequently became established as recognized netsuke types. The importance of a set of ten album leaves in the British Museum, depicting *inrō*, netsuke, *ojime*, *sagemono* and other accessories, should be mentioned in the context of early netsuke. Their unusual subject-matter and uncertain original form have cast some doubt over their dating, although some time within the

77 *Sagemono* and dress accessories. Album leaf. Ink and coloured pigments on gold-leafed paper. 1650–75. An *inrō* and pouch are suspended from a seal netsuke with the head of a *shishi*, probably of Chinese manufacture. Tying strips of fabric, usually of red colour, around the cords appears to have been a short-lived phenomenon of *c.* 1650–75.
© The Trustees of the British Museum. 1978,0724,0.5

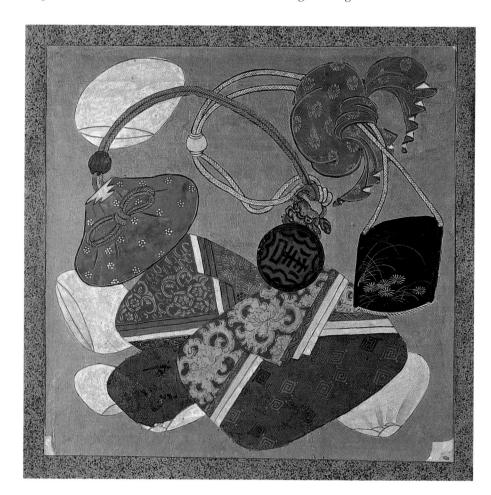

seventeenth century seems assured. Since this was the period when *obiguruma* and *kara* netsuke gave way to *manjū* and *kagami* forms, it is interesting to note from these paintings what form these took and what methods were used to tie the cord ends. Moreover, compared to the scale of other seventeenth-century pictorial sources, those of the British Museum are remarkably clear and detailed. The album leaves reveal three seal netsuke, probably of Chinese origin and all of types that are illustrated in *Sōken kishō* (Plate 77),[2] three natural gourd netsuke and another netsuke, possibly of the *hako* (box) form. In addition, there are also five netsuke that appear to be flat, decorated metal discs of irregular outline. Each has a central hole through which the cords pass before they are tied in a bulky knot to prevent them slipping back again. There are also two examples that depict a strip of red fabric tied round an *inrō* cord (see page 24). All these features are consistent with a mid-seventeenth century date at the earliest.

By the second half of the seventeenth century at least, the term 'netsuke' was used to refer to a variety of different types, including *katabori* netsuke, although other terms were sometimes given for specific forms. The popular novelist Ihara Saikaku (1642–93), for example, uses the word in the 1680s (see page 41). *Kōshoku ichidai onna* ('The woman who spent her life in love'), one of Saikaku's works, is probably the earliest literary source for a *katabori* netsuke.[3] It describes a shop window in which are displayed a netsuke

78 *Shijō Kawara Yūrakuzu* ('Illustrations of pleasure at Shijō Kawara Yūrakuzu') (from a pair of folding screens). This detail shows an early *katabori* netsuke in the form of a *shishi*. Ink and coloured pigments on gold-leafed paper. 1624–44. Seikadō Bunko Art Museum. Image Archives / DNPartcom.

in the form of a *kara-shishi* ('Chinese lion') and an old *tsuba* (sword guard). This suggests that by the time of publication in 1686, *katabori* netsuke were already in wide circulation.

The crucial role played by pictorial sources in our knowledge of early netsuke has already been discussed on pages 21–24. Recently another pair of screens, *Shijō Kawara Yūrakuzu* ('Illustrations of pleasure at Shijō Kawara') in the Seikadō Bunko Art Museum, has been shown to reveal most interesting information concerning netsuke.[4] The screens portray five men wearing an *inrō* and pouch. The netsuke of one ensemble reveals a *katabori shishi* (Plate 78), while it is hard to make out the details of the other netsuke, even though the scale is quite large. One possible reason for this could be that the artist has gone to considerable lengths to exaggerate the size and detail of something that is essentially new and unfamiliar; alternatively, it was truly larger than the average netsuke. As was frequently the case with screens of this type and period, the *Shijō Kawara*

Yūrakuzu is unsigned and undated, but has been attributed to the Kan'ei era (1624–44). Although the *katabori shishi* netsuke described by Saikaku sounds very similar, the painted version on this screen may predate it by some 50 years. This has enormous implications for the study of *katabori* netsuke which, for lack of hard evidence, have always been dated to the late seventeenth century at the earliest. Does the netsuke on this screen at last provide incontrovertible proof, or is it an adapted Chinese carving, like the *shishi* seal netsuke on the British Museum album leaf? I have long been of the opinion that some *katabori* netsuke were likely to have been produced during the first half of the seventeenth century when Chinese seals carved in the round were known in Japan. Since some were adapted as netsuke, surely it was only a matter of time before similar examples were made specifically as *katabori* netsuke in Japan?

The Phase of Chinese Predominance

During the formative period of *katabori* netsuke, the influence of China was paramount. Although trade was at the heart of intercourse with foreign countries, the late sixteenth century also coincided with Japan's awakening to the outside world. Relations with China, Japan's mainland neighbour and traditional source of cultural borrowings, were considered advantageous at this time. In addition to trade, Japan also adopted neo Confucianism from China to help legitimize Tokugawa rule.

79 Baku. Ivory. 1675–1750. H. 4.3cm. 407–1904. Dresden Bequest.

Late Ming-Dynasty China experienced something of a printing boom, with various key works reaching Japan in significant numbers. Those that were illustrated presented an exotic mixture of fact and fiction that was highly appealing. One of the most important was the profusely illustrated Chinese encyclopaedia, *Sancai tuhui* ('Tripartite picture assembly'), published around 1610, itself compiled from various earlier illustrated books. Of particular interest were the illustrations of fabulous beasts and mythical people, many of which subsequently became fundamental to the netsuke repertoire. These included the *qilin* (Jap: *kirin*); *mai*, an amalgamation of tapir, rhinoceros, ox and tiger, with an elephantine trunk, while the Japanese version, *baku*, appears as a feline beast with a short, curly trunk, and the power to devour bad dreams (Plate 79); *suani* (Jap: *shishi*), usually referred to as a Chinese lion (Plate 80); and the creature from *yumin guo* ('land of winged-men') that hatches from an egg, resembling the Japanese *tengu* (Plate 62).[5] The popularity of *Sancai tuhui* in Japan was such that a Japanese

version, *Wakan sansai zue*, was published by Terajima Ryōan in 1716. This, however, was somewhat altered for the Japanese market. Under the section on 'personal accessories', for example, it includes an entry for *inrō*. Although netsuke are not specifically mentioned, one rudimentary example is illustrated attached to an *inrō*. Another Chinese book that was enormously influential, *Shanhaijing tu* ('Illustrated book of hills and seas'), was published in the second quarter of the sixteenth century, although it was based on an earlier version without pictures, the *Shanhaijing*, that dates back, in parts, to the Warring States period (475–221 BC). In a manner similar to *Sancai tuhui*, the *Shanhaijing tu* also gave prominence to the description and illustration of fabulous creatures, such as *ashinaga* ('long legs'). Other prototypes for fabulous creatures may also be found in Japanese encyclopaedias of slightly later date, such as the *Kinmō zui* ('Illustrated primer') published in 1666. In addition, it also included *tenaga* ('long arms'), who subsequently became combined with *ashinaga* (Plate 41), *konron* (dark people) and *oni* (demons), together enormously increasing the netsuke carver's visual repertoire.

During the late Ming Dynasty, a number of works concentrating on immortals, spirits and deities was also published. Most notable among them was the profusely illustrated *Liexian quanzhuan* ('Complete stories of immortals'), published in 1600; this was based on the original *Liexian zhuan* ('Classified accounts of deities'), compiled during the Eastern Han period (AD 25–220). Such was its popularity that, in 1650, it appeared

80 *Shishi* and young. Ivory. 1675–1775. L. 4.76cm. 808–1907. Pritchett Gift.

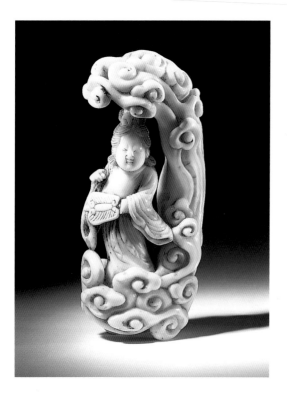

81 Immortal in a cloud. Ivory. 1675–1700. H. 7.6cm. A.732-1910. Salting Bequest.

82 The Immortal Kasenko. *Yūshō ressen zenden* ('Complete illustrated lives of immortals'), edited by Wang Shizhen. Woodblock-printed book, Vol. 6, published 1650.

in a Japanese edition as *Yūshō ressen zenden* ('Complete illustrated lives of immortals') with little modification to the original. The *Liexian zhuan* gives a written account, with an accompanying illustration, of nearly 500 deities, particularly immortals (Chinese: *xian* or *xian ren*; Jap: *sen* or *sennin*). Immortals or transcendents were essentially practitioners of religious Daoism, a school of Chinese thought with its origins in the fifth to third centuries BC, which was subsequently transformed into an organized religion with a recognized pantheon of deities. Immortals were perfected beings who, through self-cultivation, were able to transcend their normal existence and take leave of their bodies.[6]

The debt to Ming book illustration of *katabori* netsuke cannot be underestimated. The fact that the arrival of books from China coincided with a nascent art form was a most fortuitous coincidence. The effect of fantastic and exotic Chinese motifs on Japanese

craftsmen of the sixteenth century must have been similar to that of chinoiserie on eighteenth-century Europe. One can see many parallels between the distinctive subjects of early netsuke and those of Chinese illustrated books and their Japanese editions, and this is corroborated by *Sōken kishō*. The essay by Shūkei, Yoshimura Shū zan's (d. 1773) son, states that his father made extensive use of motifs from both the *Shanhaijing tu* and *Liexian zhuan*. It is quite possible that the figural netsuke framed by clouds on three sides (Plate 81) is an adaptation of an immortal, He Xiangu (Jap: Kasenko), from the *Liexian quanzhuan* or *Yūshō ressen zenden*, the illustration being identical in both (Plate 82). As noted before, it is quite acceptable that elements unsuited to the netsuke form, such as the protruding fly whisk, were modified into a compact fan. Doubtless other craftsmen also used different Chinese books as source material. Before long, Japanese books reproduced similar motifs, thus permanently entering the repertoire of Japanese art and becoming highly influential as design sources in their own right.

The appearance of Chinese illustrated books in Japan also coincided with the development, from around 1580 onwards, of a thriving ivory carving industry centred on the coastal regions of southern China, particularly Zhangzhou in Fujian province. This catered in large part for the Portuguese and Spanish who, by the late sixteenth century, had a strong presence on the Asian mainland. Since trade and proselytizing for the Catholic Church went hand in hand, the production of religious imagery was an essential part of their needs. Chinese craftsmen were commissioned to copy Christian ivory figures based on European Gothic prototypes, mainly for the Spanish at Manila.[7] Fundamental to Christian figure-carving were images of the Madonna and Child, while a parallel could be made with the Chinese *songzi* ('child-giving') Guanyin, often depicted in a female manifestation holding a baby.[8] According to Buddhist iconography, Guanyin (Sanskrit: Avalokiteśvara; Jap: Kannon) was the bodhisattva thought to embody compassion, who appeared in a number of manifestations. A most unusual subject for netsuke, Plate 83 possibly reflects a japanization of this combination of Madonna and Child with *songzi* Guanyin into a secular woman and child. Although it is tempting to date this to the seventeenth century, the distinctive hairstyle indicates that it is more likely to be early eighteenth century.

In addition to Christian imagery, a considerable output of the Chinese ivory carving industry also consisted of figures of popular gods and immortals, such as Zhongli Quan, who played a large part in daily life (Plate 84). Immortals were normally portrayed as hermit or rustic figures with a cape or skirt of feathers or distinctive leaves, commonly mugwort. It is also interesting to note how illustrations in the *Liexian quanzhuan* often depict immortals within a border of clouds; in much the same way,

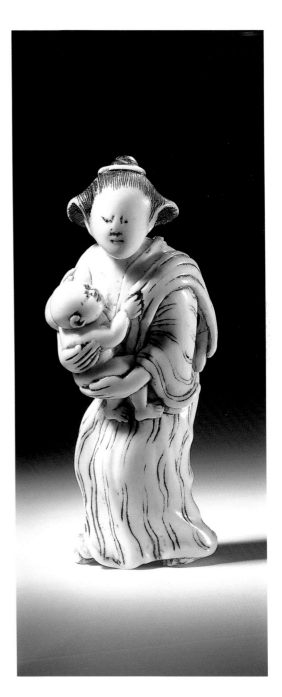

83 Woman and child. Ivory.
1650–1700. H. 7cm.
A.875–1910. Salting Bequest.

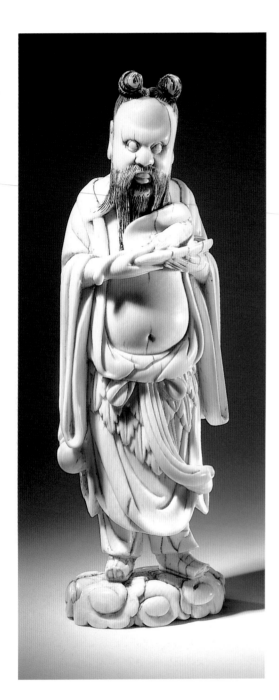

84 Zhongli Quan, with fan
and tortoise on a cloud-scroll
base. Ivory. Chinese;
c. 1580–1644. H. 14.7cm.
FE.4–1977.

Zhongli Quan stands on a cloud base. The immortals most widely interpreted in netsuke form were Gama (Chinese: Xia Mo) and Tekkai (Chinese: Tie Kuai) Sennin with their attributes. Whereas the former is frequently portrayed with his three-legged toad, the latter is shown exhaling his spirit from his body, a composition difficult to realize in the *katabori* form. For this reason, he is more commonly depicted with his iron crutch, another attribute. Similarly, Chōkarō (Chinese: Zhang Guolao) is shown with his companion, a white mule, which could be stowed away magically when not required, often in a gourd, and Kinkō (Chinese: Qin Gao) was invariably pictured riding on a carp.

Whether as items of trade or as personal belongings, a significant quantity of Chinese ivory carvings reached Japan. In addition to figure carvings was also a number of miscellaneous items, some of which are described and illustrated in *Sōken kishō* (Plate 60).[9] These include seals, sword hilts, cane handles, belt hooks and carvings of erotic women masquerading as 'doctor's ladies'. As they were not intended as netsuke, cords were attached in appropriate places or holes were drilled for them. The sculptural carving on the top of many seals, which are thought to have reached Japan in considerable numbers, was yet another important contributory factor to the development of *katabori* netsuke.

The constituents of another distinctive group of early *katabori* netsuke were produced from around the mid-seventeenth to mid-eighteenth centuries. They portray standing figures of exceptional height (generally 10–16cm), which taper towards the feet. This is accommodated in the design either by feet that are proportionally small or by a figure standing on one leg, with the other foot clumsily twisting round it. In the case of the rarer animal netsuke, the creature was made to stand up rather unnaturally on its hind feet, which are close together. The netsuke also bear distinctive *himotōshi*, one being noticeably larger than the other to accommodate and secrete the cord knot. This is also a characteristic of netsuke of this date rather than exclusively of tall figures. Although the V&A only possesses one tall figure netsuke in its collection it would appear, on stylistic grounds, to be a later example (Plate 85).

The reason for the excessive height of these netsuke has proved to be something of a puzzle. It is quite possible that they were produced as a direct result of, and in imitation of, Chinese ivory figure carvings that were of considerable height, averaging between 20 and 30cm. Since such measurements were excessive for netsuke, it is likely that *netsukeshi* made them as large as was practicably possible. This also coincided with the early practice of attaching both an *inrō* and a pouch from a single netsuke. Although it would be convenient to assume that this would have necessitated a very large netsuke, this is not borne out by pictorial sources. The fact that each had their own cord, however, resulted in an extremely big

knot when they were tied together, requiring one *himotōshi* to be larger than average (Plate 16). It has also been suggested that the reason for the size of the netsuke was to support large items of *sagemono*. There seems little evidence for this, however, since both large and small accessories were suspended from the sash right from the outset. Just as many different types of *inrō* and other *sagemono* existed from an early date, it would seem likely that there was an equally large variety of different forms of early *katabori* netsuke. Since surviving pictorial sources suggest that the practice of suspending both an *inrō* and pouch from a single netsuke died out from the late seventeenth century onwards, this may well have been a contributory factor to the ultimate decline of tall figure netsuke.

The eighteenth century witnessed a partial shift in interest towards smaller standing figures of apparent Western appearance and clothing which, judging by surviving examples, were produced in comparatively large numbers. The timing of this phenomenon, however, was curious. By 1641, the policy of seclusion (known as *sakoku*, 'closing the country') was complete, and all Europeans had been expelled from Japan. The only exceptions were the Dutch, who continued to trade under strictly controlled conditions from the island of Dejima. However, the Japanese fascination for people of such different physical characteristics, clothing, customs and accoutrements, continued.

Netsuke that belong to this group display certain shared characteristics. They most commonly depict a man holding a bird, dog, child or inanimate object, such as a musical instrument, or alternatively with a monkey on his shoulder. Although the man bears the physical characteristics of a Westerner, notably a Dutchman, he frequently wears clothes characteristic of another country, particularly China. Other inexplicable combinations are also to be found, such as a Dutchman carrying a Chinese child. The many foreign influences received by the Japanese during the sixteenth and seventeenth centuries, whether from China or the West, from book or real life, fused together, resulting in a homogenized 'otherness'. There are even netsuke of *sennin* that reveal distinctly Western faces (Plate 86). Factual accuracy became unimportant, especially as there was little means of verification. For this reason, a number of authors have recently adopted the term *ijin* ('people of difference') for these figures of indeterminate origin.[10]

It would seem highly probable that two additional sources influenced *ijin* netsuke. The first was a type of carved and painted wooden doll, known as *Saga ningyō* ('Saga doll'), made during the seventeenth and eighteenth centuries.[11] Such dolls most commonly portray Hōtei with *karako* ('Chinese child') and, more importantly, children, holding a bird or dog, dressed in clothes decorated with wave crests. It is not hard to imagine a natural progression over a period of time from dolls of this type to netsuke of

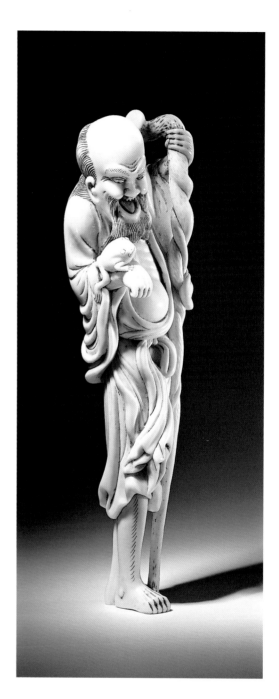

85 Gama sennin with his toad. Ivory. 18th century. H. 13.2cm. A.762-1910. Salting Bequest.

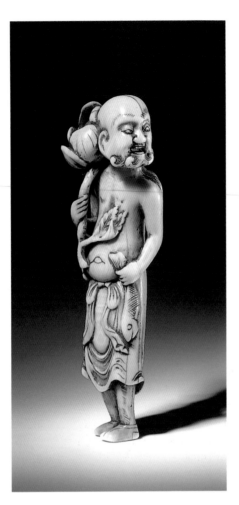

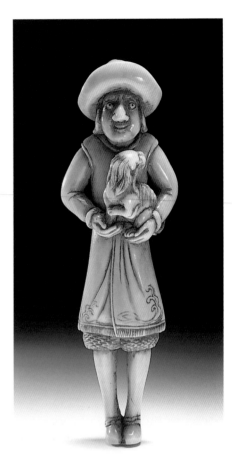

86 Immortal holding a fish and lotus flower. Ivory. 1675–1750. H. 9cm.
FE.90–1996. Schwaiger Bequest.

87 Dutchman holding a dog. Ivory. 18th century. H. 10cm.
FE.284–1995. Schwaiger Bequest.

Dutchmen with elaborate coats, decorated with distinctive wave crests that are probably of Chinese origin (Plate 87). Additional visual information might also have been provided by Nagasaki woodblock prints and paintings, which depict the Dutch, Chinese, as well as other foreigners and non-Japanese elements.[12] This would also account for the intricate portrayal of details of dress, such as buttons, ruffs and footwear. It is also interesting to note the manner in which the Dutchmen's eyes are portrayed; compared to those of Japanese figures, they appear round and almost bulging out of their sockets.

The Phase of Japanese Resurgence

If the early development of *katabori* netsuke owed an enormous debt to China, then the next phase, from around the mid-eighteenth century onwards, reflects a resurgence of native interests. This manifested itself not only in a preference for Japanese subjects (Plate 88), Japanese myths (Plate 89), heroes and gods, but also in the Japanese appreci-

ation of nature. This shift in imagery also coincided with the increasingly naturalistic portrayal of netsuke. One of the most surprising features of early netsuke is the lack of realism in their execution. Those unfamiliar with Japanese art might simply assume this results from a lack of expertise and maturity in the art of carving, but one only has to look at Buddhist sculpture of the Kamakura period (1185–1333) to see that this was not the case. It is evident from the outset, therefore, that realistic portrayal was not the *net-sukeshi*'s main objective.

The emergence of realism in Japanese art during the second half of the eighteenth century can be attributed in large part to the influence of Western painting. Since direct contact with Europeans was strictly limited to a handful of Dutch trading on Dejima, the books they brought with them had a great influence, becoming the main source of Western knowledge in Japan. The information disseminated through such works, termed '*rangaku*' (Dutch studies), resulted in the introduction of drawing from nature, the use of perspective, light and shade. These new features of Japanese painting were particularly evident in the work of Shiba Kōkan (1738–1818). Realism was also reflect-ed in the paintings of the Maruyama-Shijō school, so called after its founder Maruyama Ōkyo (1733–95) and Matsumura Goshun (1752–1811), whose studio was situated in the fourth ward (*shijō*) of Kyoto. This was reflected in the field of netsuke by keen observa-tion and attention to detail (Plate 90), especially in the depiction of animals, which became a speciality of *netsukeshi* from Kyoto. The somewhat simplified animal carvings of the early eighteenth century (Plate 91), therefore, gradually gave way to their more meticulous portrayal (Plate 92). This can be seen clearly in such details as the markings and fur of an animal, as well as eyes that were frequently inlaid with different materi-als. In the late nineteenth and early twentieth centuries, the quest for realism culminat-ed in elaborate carvings of enormous technical virtuosity. It is works such as these that have proved the most popular with Western collectors, forming the benchmark for

88 *Saru* (monkey) doll and bell. Ivory, red and gold lacquer. Signed 'Ryōmin' with a *kaō*. 1775–1850. H. 2.9cm. W.188:2–1922. Pfungst Gift.

89 *Oni* weeping over the severed arm of Ibaraki, the Rashōmon demon. Ivory. 1775–1850. L. 4.8cm. This alludes to the legend of the 11th-century hero Watanabe no Tsuna and the demon terrorizing Kyoto's Rashōmon gate. Although the hero did not vanquish the demon, he succeeded in cutting off one of his arms. 467–1904. Dresden Bequest.

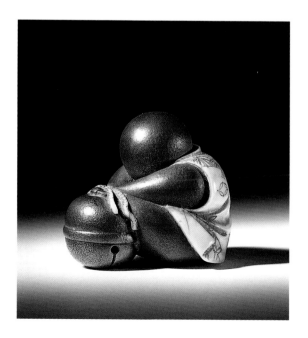

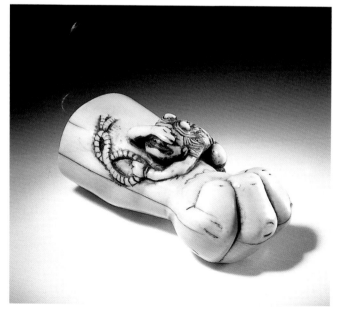

90 Skull. Ivory. 1800–1900.
L. 4.7cm.
457–1904. Dresden Bequest.

91 Dog. Ivory. 18th century.
H. 5.5cm.
A.44–1930.

92 Cicada. Wood. Signed
'Harumitsu', 1800–1875.
L. 5.7cm.
A.993–1910. Salting Bequest.

netsuke in general. It should be remembered, however, that naturalistic portrayal was not always the desired effect. There are, for example, a significant number of nineteenth-century netsuke carved in a relatively simplistic manner, which makes the dating of netsuke more complex.

Later Netsuke

It is a widely held view that *kagami* netsuke became more numerous after the immediate destruction and fires that followed the great earthquake of 1855. It has been argued that *kagami* netsuke were quicker and easier to produce than *katabori* netsuke as vital replacements. This may well be partly true, but the case has no doubt been overstated; it is just as likely that a new fashion had been ushered in. With its rounded corners and relatively smooth back that lay comfortably against the body, the *kagami* netsuke may also have re-emerged as a reaction against netsuke with increasingly sharp protuberances. It also coincided with the fashion for a distinctive type of *manjū* netsuke, which was larger and heavier than previously; it was circular or rectangular with rounded corners and edges (Plates 13 and 68). Such netsuke were often made of a solid piece of ivory, with decoration in deep sunken relief (*shishiaibori*). A depression in the centre of the netsuke provided the fixing point for the cord attachment. This was achieved either by a metal ring or an ivory plug with a hole that moved up and down, thereby secreting the cord knot (Plate 68). As with Ukiyoe prints of the nineteenth century, the subjects of some contemporary netsuke included myths and legends, gory battle scenes, as well as the supernatural. Such netsuke of the above type, which invariably date from the late nineteenth or early twentieth century, were used to support large items of *sagemono*, particularly smoking sets, often using fine metal chains instead of cords.

It is an interesting phenomenon that although at the end of the nineteenth century netsuke were no longer used, there has never been a time when their production has

ceased altogether. This is undoubtedly because netsuke became collectors' items, particularly in the West, while the knowledge and skills for making them, such as wood or ivory carving, are not specific to netsuke. As the interest in netsuke among collectors went from strength to strength, a number of noted carvers who had been trained in a traditional workshop returned to the craft during the 1940s, maintaining and promoting the highest of standards.[13] A few decades later, a new generation of collectors both in Japan and the West had stimulated the emergence of a new group of *netsukeshi* whose work began to match the best of their Edo-period predecessors. New and informative books on netsuke fuelled the growing interest, such as the publication of the *Netsuke Kenkyukai* in 1973. Despite various changes of name, this enjoys a wide circulation today as the *International Netsuke Society Journal*. In 1977 the Netsuke Kenkyukai was established for carvers, becoming the Netsuke Carvers' Association in 1982. This subsequently became the International Netsuke Carvers' Association in 1989.

The fact that netsuke were produced specifically as collectors' items from the late nineteenth century onwards poses something of a dilemma. Can netsuke be considered true 'netsuke' if they were never intended for use? In my opinion they can, provided they still fulfil all the necessary criteria of a true netsuke, such as small size, a fairly compact form and the means to attach a cord. It has sometimes been argued that a modern netsuke does not acquire a natural patina brought about through natural wear, tear and age. Yet a fully functioning netsuke of the nineteenth century or earlier, when new, was in exactly the same position as a contemporary one, but was not considered any less a netsuke because it appeared pristine. Indeed, a much-loved netsuke produced in recent years still has the ability to inspire its owner to handle and fondle it, ultimately producing its own type of patina.

1 For several examples, see Haino (1998), pl. 126.

2 Illustrated in Arakawa (1983), p. 213.

3 Arakawa (1983), p. 196.

4 This information was discovered by Toshiko Tamamushi, Yukari Yoshida, Nori Watanabe and Robert Fleischel, and published in Kurstin (2002).

5 Although the *tengu* is normally thought to be of purely Japanese origin, it is found in this Chinese source.

6 Little (2000), p. 143 and p. 313.

7 Gillman (1984), pp. 36–40.

8 Gillman (1984), fig. 15.

9 These are illustrated, and the text translated, in Arakawa (1983), pp. 211–13.

10 For example Screech (1995).

11 This connection was first proposed by Joe Earle, using information from Kawakami (1995), p. 19.

12 Mody (undated, reprint of 1939)

13 Welch and Chappell (1998), p. 166.

7 | Netsuke Craftsmen and Centres of Production

W hen netsuke first reached the West, enormous emphasis was placed on the craftsmen who made them. It is probably no exaggeration to say that the backbone of early Western studies of netsuke was the compilation of meticulous genealogies of craftsmen, often at the expense of an impartial assessment of their artistic abilities. Although well intentioned and covering rudimentary groundwork, the basis of such early taxonomy was generally not entirely sound. There was, for example, little understanding of the problems and pitfalls of the use of Japanese art names, while most signatures were taken as genuine. There was as well a dearth of Japanese literature on netsuke, while the *Sōken kishō*, the one main exception, is probably not wholly impartial.

The traditional method of training Japanese artists and craftsmen was through a system of apprenticeship in an established workshop. The normal age for a boy to be apprenticed to a master was between 11 and 13, although a talented individual could join a workshop at a later age. Once netsuke became popular and craftsmen began to specialize in their production, family lines or 'schools' became established in the traditional way. There were exceptional cases, but in general the production of netsuke relied on the skills handed down from master to pupil within a workshop. In an ideal situation, the main line of a family workshop would pass from the father to the most talented son. If this were not possible, then it was customary for a relative or gifted pupil to succeed to the title as master. Although the wages of a *netsukeshi* were low, the most able and fortunate might receive the patronage of the wealthy and influential.

From the late eighteenth century onwards, it became increasingly common for a netsuke to be signed with the name of the craftsman who made it. Apart from the personal and family name, a craftsman normally adopted a *gō*, a professional or 'art' name, which may have changed at various times throughout his career. In addition, the not uncommon practice of adopting the same name as the previous or earlier head of the family has often caused endless problems. Retrospectively, such individuals could be distinguished by the addition to the name of 'I', 'II' and so on. Although, on the one hand, this practice may have led to confusion, on the other it often provides clues as to the course of a master-pupil relationship. A characteristic of the lineage of *netsukeshi* was that the master frequently allowed a highly skilled pupil to use one of the characters from his *gō* and combine it with one or more of their own, thereby forming the pupil's own *gō*.

A master *netsukeshi* would not put his name to an item if he were not completely satisfied with it, even if some parts were executed by the most skilled pupils. Yet there are netsuke with the signature of a master that do not match up to the high standards

Opposite: Detail from Plate 100.

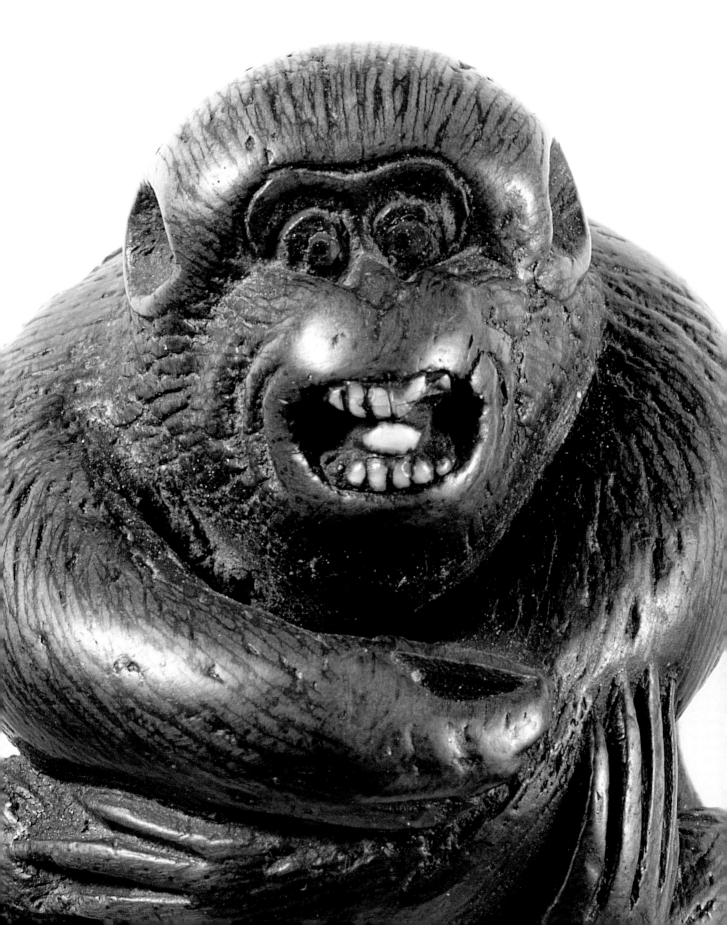

of his work, and these are undoubtedly the hand of another. How, then, can one recognize what is likely to be the genuine work of a particular *netsukeshi* from what is not? This, unfortunately, takes years of experience and can never be wholly taught. One must be able to detect a thorough grounding in the subject on the part of the *netsukeshi*, good composition (often ingeniously exploiting some peculiarity of the material), the choice of appropriate, quality materials, competency of carving, and an intuitive 'feel' for what is right. If a netsuke were signed, the minimum information would include the name of the *netsukeshi*, possibly followed by a *kaō*, a personal cypher or artistic monogram. A signature might also include the craftsman's age, especially if he were over 60, together with the place of manufacture and such terms as '*hōgen*' or '*hōkkyo*', honorific titles awarded to painters and sculptors. Occasionally, information would also be given concerning the details of manufacture, such as the name of a patron, or painter whose design was being copied. The situation was complicated by the addition of spurious signatures, particularly during the late nineteenth and twentieth centuries, although the practice of copying is already noted in *Sōken kishō* as early as 1781.

Since netsuke evolved gradually during the seventeenth century, the earliest would have been made by workers in other, related fields as a sideline or hobby. As wood grew abundantly throughout Japan, many craftsmen would have been involved in the manufacture of a wide range of wooden objects. Among these were undoubtedly wood carvers associated with Buddhist temples, images and associated paraphernalia, including miniature shrines that were popular at that time. Others probably produced *ranma*, decorative openwork transoms, along with other decorative architectural work. Yet others carved masks or made dolls.

The earliest ivory netsuke were probably carved by makers of seals and plectra for *shamisen* and other stringed musical instruments. Similarly, early metal netsuke would have been made by metalworkers fulfilling the general requirements of the population, such as sword fittings and Buddhist implements. It is not known exactly when specialist craftsmen first produced netsuke as their main or sole line of work. As early as 1690, *Jinrin kinmō zui* ('Illustrations for proper behaviour') stated that the craftsmen who were involved in ivory and horn crafts, which included netsuke, were 'concentrated around the Teramachi district of Kyoto, but could be found elsewhere, too'.[1] By the time the *Sō ken kishō* was published, in 1781, however, the production of netsuke had already become widespread.

The fact that the *Sōken kishō* lists 54 *netsukeshi* suggests that it had not only become customary to sign netsuke by this time, but that there also must have been many more who did not sign their works or were not known to Inaba. Although the majority of craftsmen were contemporaries of Inaba, a few were from an earlier period, suggesting that he was trying to legitimize and provide a tradition for a craft still in its infancy. The majority of *netsukeshi* listed in the *Sōken kishō* were from Osaka, Kyoto and Edo, in addition to Nagoya and some regional centres. Since it is beyond the scope of this book to provide an exhaustive list of *netsukeshi*, this chapter instead provides a selective overview, covering the main areas of netsuke production in the urban centres as well as in provincial parts of Japan.[2] It will also concentrate on those *netsukeshi* whose works feature prominently in the collection of the V&A, or about whom there is relatively new information.

It is evident that Inaba was not familiar with the work of all *netsukeshi* that he mentioned and, since he was from Osaka, he headed the list with Yoshimura Shūzan, a fellow resident. Since Shūzan is thought to have died in 1773,[3] a few years before the *Sō ken kishō* was published, and had already achieved considerable status as a painter and netsuke carver, he lent a certain respectability to a craft lacking tradition. Shūzan is reputed to have carved netsuke mostly from cypress, a soft wood that wears down relatively easily. It is quite possible that for this reason he originally started painting his carvings, subsequently also gaining a reputation for his unusual use of colour. Before applying mineral colours, Shūzan applied a gesso base. Through wear and tear, the coloured surface rubbed off in parts, resulting in an effect not altogether unpleasing. According to his son, Shūkei, writing in the *Sōken kishō*, Shūzan is known to have made widespread use of Chinese book illustration (page 79) as source material for his mythical creatures, which he freely adapted. Shūzan did not sign his netsuke, which makes identifying genuine work extremely difficult; Inaba mentions that there were already many fakes attributed to him at the time of publication. However, many collections today reveal a significant number of netsuke that bear the signature of Shūzan. Carved from cypress wood and painted in gaudy colours, invariably depicting actors and gods of good fortune, these date from the mid- to late nineteenth century (Plate 93). Although the *Sōken kishō* states that he was very fond of carving netsuke, Shūzan ceased making netsuke in middle age, concentrating instead on painting, for which he was better known.[4] He also produced illustrations for woodblock-printed books, most notably *Wakan meihitsu gaei* ('Glories of Japanese and Chinese painting'), published in 1750, and *Wakan meihitsu zuhō* ('An illustrated treasury of Japanese and Chinese painting'), published in 1767. Although these books were primarily aimed at aspiring artists, netsuke carvers could equally have used them as design sources.

During the nineteenth century, Osaka was renowned for two highly skilled *netsukeshi*, Ōhara Mitsuhiro (1810–75) and Kaigyokusai Masatsugu (1813–92). At the age of 17, Mitsuhiro went to live with a family in Osaka who dealt with ivory and made *shamisen* plectra. There he learnt carving by using ivory waste, ultimately being adopted by the master of the shop and becoming independent after ten years. Mitsuhiro is well known for his minutely detailed carvings of animal, vegetable and figural subjects. He worked mostly in ivory, often staining it subtly in red (Plate 94). Masatsugu had no formal training in carving, although his own enormous success forced him to take on pupils. Like Mitsuhiro, he also worked mostly in ivory, carving immensely fine detail, which earned him the reputation of being one of the most well-known netsuke carvers in Japan and the West. The fact that Masatsugu lived to see the introduction of Western dress and the fall in demand for practical netsuke directly influenced his netsuke. They are, for

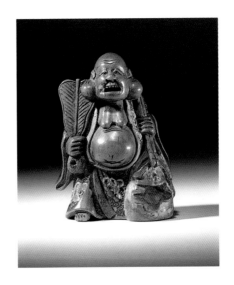

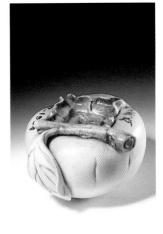

93 Hōtei, with his fan and sack. Painted cypress wood. Signed 'Shūzan'. 1850–1900. H.4.4cm.
A.72–1918. Wheatley Gift.

94 Persimmon. Ivory with red staining. Signed 'Mitsuhiro' with a *kaō*. 1825–75. H.2.6cm.
447–1904. Dresden Bequest.

95 Octopus caught in an octopus trap. Ivory. Signed 'Mitsuhiro' and 'octopus and shells by Kaigyoku' and inscribed with a poem. 1825–75. H 2.9cm.
A.55–1919. Clarke-Thornhill Gift.

example, frequently designed so that they sit solidly on a flat surface, appearing as decorative ornaments as much as netsuke. Although many of his later netsuke also possess natural features that could serve the purpose, they often do not have *himotōshi* as such. According to the inscription on the base of one such example (Plate 69), it would appear that the boar was originally one of a set of twelve carvings of animals of the zodiac. Another result of Western influence was that Masatsugu increasingly turned to the carving of *okimono*. For these he used the finest quality ivory without staining it. Another netsuke is not only important for its superb quality of workmanship and its highly playful subject, but also for its recording of the collaboration of the two great contemporary Osaka *netsukeshi*, Masatsugu and Mitsuhiro (Plate 95).

As Japan's traditional art centre and capital city, Kyoto also became one of the great centres of netsuke production. During the eighteenth century, moreover, it also emerged as the originator of classic animal netsuke. The *Sōken kishō* mentioned three contemporary master *netsukeshi* of Kyoto: Masanao, Yoshinaga and Tomotada. Little is known about them, and the V&A does not possess any netsuke by Masanao or Yoshinaga. Yoshinaga is known to have had at least two pupils, Yoshitomo and Yoshimasa, both of whom used the same character for 'yoshi' as their master. Despite the fact that there is not a large number of surviving works by Masanao, he has gained an enormous reputation as an extremely fine *netsukeshi*. By contrast, works by Izumiya Tomotada are far more numerous, even allowing for the fact that he is one of the most widely copied *netsukeshi*. Since there is a large corpus of netsuke that is of good or exceptional quality purported to be by Tomotada, identification is by no means straightforward. Although the *Sōken kishō* mentions that he excelled in the carving of oxen (Plate 96), he is also widely associated with netsuke of tigers; in both cases, the animals were frequently depicted either singly or in a pair of mother and young (Plate 52).

Tomotada is known to have had two pupils, Tomotane and Okatomo, both of whom used the '*tomo*' character of their master's name. Okatomo (active 1781) is also mentioned in the *Sōken kishō* without any additional detail, although he is widely associated with netsuke of bird subjects, especially quail and millet (Plate 97). Since Okatori (active late 18th–early 19th century) was the younger brother of Okatomo, they also

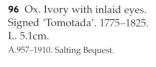

96 Ox. Ivory with inlaid eyes. Signed 'Tomotada'. 1775–1825. L. 5.1cm.
A.957–1910. Salting Bequest.

shared the same '*oka*' character of their name. The members of yet another Kyoto-based family, which was founded by Nagai Rantei (active late 18th–early 19th century), shared the same '*ran*' character in their name. Rantei worked predominantly in ivory, carving a wide range of themes, especially animals and figural subjects. Reikichi quotes a story, which may well be apocryphal, that 'at the request of Prince Ninnaji, [he] made [a] nut carving of 1,000 monkeys so tiny that the individual monkeys could not be seen with the unaided eye.'[5]

Of the craftsmen listed in the *Sōken kishō*, only a small number are recorded as being residents of Edo, the centre of government. This is in sharp contrast to some 50 or 100 years later when Edo boasted the largest number of *netsukeshi*. Perhaps the most important Edo *netsukeshi* to be mentioned in the *Sōken kishō* were two members of the Deme family, Deme Uman and Deme Jōman, probably father and son. They are both listed as mask carvers who produced mask netsuke of rare quality as a hobby. Deme Eiman (d. 1705), the grandfather of Uman, the originator of the long Deme line, specialized in mask netsuke (Plate 48). Since certain mask makers were awarded the honorary title *tenka ichi* ('unsurpassed under heaven') for their exceptional work, the term was also adopted by some members of the Deme family for their netsuke, especially by Deme Uman. Mask netsuke, which are invariably made of wood, have a horizontal bar at the back, which not only serves to attach the cord, but is also where a signature could be added. The large number of mask netsuke that bears the Deme name undoubtedly includes many late examples or outright fakes.

Apart from the Deme family and their specialist line of netsuke, Miwa may be considered the originator of Edo-style netsuke, which ultimately became renowned for figural subjects (Plate 100). Since successive generations used the name 'Miwa', this clearly demonstrates the difficulties involved in identifying the different generations. The first, Miwa Yūkan (active 1781), was a sculptor who made netsuke as a hobby. He carved figural subjects exclusively in wood, mostly cherry or imported hard woods, lining the *himotōshi* with ivory. He may also be the same person as Miwa Zaiei, who died in 1789. Miwa Rikan came later, although nothing is known about him. There are also many netsuke signed 'Miwa' that appear to be of even later date.

Whereas Kyoto was considered the most innovative centre of netsuke manufacture during the eighteenth century, Edo came into its own during the nineteenth. Of the numerous craftsmen who worked in Edo at this time, it is worth mentioning Yamaguchi Tomochika (1800–73) and his two followers of the same name. They are mostly associated with detailed, figural netsuke and *okimono*. Masatoshi (d. 1884), another member of the Tomochika school, is particularly renowned for his netsuke in the form of land-

97 Quails on millet. Ivory with inlaid eyes. Signed 'Okatori'. 1775–1825. H. 2.9cm.
A.975–1910. Salting Bequest.

98 Imitation peach stone, with dog, monkey and pheasant; inside with Momotarō. The dog, monkey, pheasant and boy allude to the story of Momotarō, who was found inside a peach. Stained ivory, inlaid with mother-of-pearl, shell and horn; gold lacquer interior. Signed 'made by Shibayama'. 1850–1900.
L. 4.2cm.
W.197–1922, Pfungst Gift.

scapes that bear many similarities to decorative carvings. Yamada Hōjitsu (d. 1872), however, is considered by some to be the finest of Edo *netsukeshi*, even though his total output was comparatively low. This may be explained by the fact that, as a samurai, he received a government stipend and was under less financial pressure. He also enjoyed the patronage of the *daimyō* of Tsugaru, and possibly even the *shōgun* himself. Apart from a small number of *katabori* netsuke, he is better known for ivory *manjū* netsuke that are carved almost as though he were painting. The *manjū* are slightly convex and invariably decorated in sunken relief; this involved carving down so that the highest parts of the design were level with the original surface. This effect was undoubtedly influenced by a similar metalwork technique known as *shishiaibori*, which was developed slightly earlier by Sugiura Jōi (1701–61) and used on sword fittings.

The last netsuke school based in Edo was the Sō school, whose members continued producing netsuke well into the twentieth century. Their period of production coincided not only with the introduction of Western dress, rendering netsuke redundant, but also with the problem of trying to earn a living wage from their craft in the modern age. Despite the fact that the school is of considerable importance, the V&A does not possess a single work by any of its members. For this reason, the Sō school will not be examined in anything approaching the depth it deserves. Following the founder, Miyazaki Jōso (1855–1910), the school boasted a number of extremely skilled craftsmen, most notably Morita Sōkō (1879–1935), Sōsui (1911–72) and Shōko (1915–70). Work of the Sō school is characterized by use of the best materials, predominantly wood, combined with exceptionally high-quality carving in a detailed, realistic manner. Since they were rarely intended for use, moreover, they frequently reveal fragile elements that would not have survived on traditional, functional netsuke.

Roughly contemporary with Jōso was another Tokyo carver, Suzuki Tōkoku (1845–1913), although they represent two extremes of a tradition. Whereas the Sō school may be considered the epitome of traditional taste in Japanese netsuke, Tōkoku ultimately worked in styles that appealed to Western taste. As a delivery boy during his apprenticeship to an antique dealer, Tōkoku was exposed to carvings that decided him on his path as a *netsukeshi*. He was essentially self-taught, becoming acquainted with a wide variety of materials and techniques, including inlay. Although he worked in the *katabori* form, he is more widely known for his *ryūsa* netsuke, often with inlays of metal and other materials (Plate 17). This type of work has many similarities with that of Shibayama-style decoration, which tends to be more ornate and fussy. Although the Shibayama family has its origins in the late eighteenth century, the name became generic with a particular style of workmanship that was popular during the second half of the nineteenth century and was very much in keeping with Western taste. In its fully developed form, Shibayama work is characterized by encrustations of minute pieces of bone, ivory, shell and hardstones in a variety of surfaces, particularly lacquer or ivory, most commonly in the *inrō* format, but also found on netsuke (Plate 98).

Although Asakusa is part of Tokyo, it produced a number of distinctive *netsukeshi* during the late Edo and Meiji periods. In the West, these carvers are classed as belong-

ing to the Asakusa school, whereas the Japanese use the term 'Kokusaibori' ('Kokusai carving'), the unifying style in which they work. Contrary to popular belief, however, its greatest exponent, Kokusai (?–1894), did not live in Asakusa although he was apprenticed for four years to the carver Gyokuyosai who lived there.[6] Kokusai has a dual claim to fame, as father of Ozaki Kōyō (1868–1903), one of the most popular novelists of the time, and as a highly eccentric and gifted *netsukeshi*. Although the family originally had a rice-dealing business, prevailing conditions forced it to close, with Kokusai turning instead to carving.[7] Because Kokusai did not produce enough to live on from his carvings alone, he also became a *hōkan* (jester or storyteller), for which he always wore a red jacket, acquiring the nickname Akabaori ('red jacket') Kokusai. Kokusai worked in a distinctive and highly original style that is easily recognizable, producing not only netsuke but, among other items, pipe-cases, hairpins, tobacco pouches and chopsticks as well. He worked almost entirely in stag antler, a comparatively cheap material, exploiting its natural shape to produce pipe-cases, *sashi* and *obihasami* netsuke, although rounded *manjū* and *ryūsa* are the most common forms. Recurring subjects of Kokusai are bats, *reishi* fungus, Buddhist motifs and wooden drums (*mokugyo*), along with many different types of scrolls and circular motifs. Above all, he frequently treated his themes with enormous originality and humour. The fact that he used to indicate he was at home by placing a red, wooden temple gong on the lintel of his gate[8] may possibly explain his frequent use of the temple bell motif (Plate 31). Kokusai invariably signed his work with either 'Koku' or 'Kokusai' in full. Occasionally the signature is hidden; it is only when the netsuke is separated into two that the signature is clearly revealed inside (as with Plate 99, for example). A wooden *katabori* netsuke of a monkey represents an unintentional combination of the skills of Kokusai and Miwa (Plate 100). Presumably a treasured netsuke by Miwa suffered damage along the back of the monkey; this was repaired by Kokusai, who covered the offending part with a stag antler plaque bearing his name for the repair.

Kokusai did not have any pupils as such, nor can one speak of a Kokusai school in the true sense of the term. Rather, a strong affinity existed between a number of *netsukeshi* over whom Kokusai exerted an enormous influence. Among these, two deserve particular mention, Masayuki (Plate 51) and Rensai (both mid- to late 19th century).

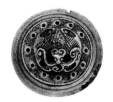

99 *Manjū* netsuke. Bat. Stag antler. Signed 'Koku', 1850–1900. H. 2.1cm.
W.95B–1923. Hearn Gift.

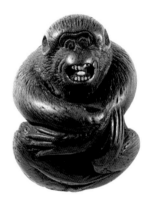

100 Monkey. Wood with ivory teeth. Signed 'Miwa' and 'repaired by Koku'. 1800–1900. H. 4.3cm.
A.936-1910. Salting Bequest.

Regional Centres of Netsuke Production

Apart from the traditional, urban areas of netsuke production, a number of other regional centres rapidly emerged, many of which were the result of abundant supplies of local materials. Craftsmen working in Nagoya, the capital of Owari province, for example, worked almost exclusively in cherry and boxwood. Since Gifu, the capital of Mino province, was only approximately 30km from Nagoya, it is hardly surprising that there is much similarity between netsuke of the two areas. Tametaka (d. 1794), who was mentioned in the *Sōken kishō*, was the first important *netsukeshi* from Nagoya. His pupil, Tadatoshi (late 18th– early 19th century), had numerous pupils who adopted the character 'tada' in their art name. Another line of *netsukeshi* in the area stems from Tomokazu, all making use of the character meaning 'one', which can be read, among

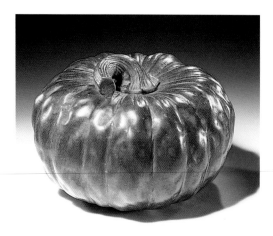

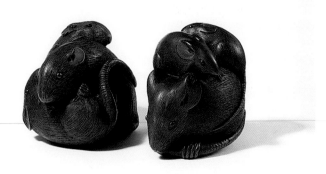

101 Pumpkin. Wood. Signed
'Ikkan'. 1850–1900. H. 4.29cm.
A.1001–1910. Salting Bequest.

102 Rats playing. Wood.
Signed 'Masateru'. 1800–50.
L. 3.4cm.
88–1907. Pritchett Gift.

Rat with young. Wood. Signed
'Masakatsu'. 1850–1900.
L. 3.6cm.
A.35-1920.Clarke-Thornhill Gift

103 Toad on broken bucket.
Signed 'Masanao'. (*left to right*):
1850–1900. L. 3.1cm.
389–1904.

H. 3.6cm.
A.71-1915. Fox Gift.

Signed 'Masamichi'.
1850–1900. H. 3.5cm.
A.984–1910. Salting Bequest.

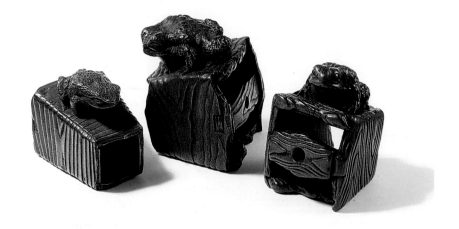

others, as *kazu* and *ichi*, resulting in *netsukeshi* such as Ittan and Ikkan. Takaoka Ikkan (1817–93), the younger brother of the head priest of Kyosenji temple, a minor branch temple in Nagoya,[9] was one of the greatest *netsukeshi* of Nagoya (Plate 101). When the temple fell on hard times, he was obliged to earn his living as a Buddhist sculptor and *netsukeshi*. Ikkan is particularly noted for his depictions of *shōjō*, a mythical creature with long red hair, much given to drinking *sake*. In the netsuke form, it is frequently portrayed fast asleep after over-imbibing (Plate 24). Although Tadatoshi seems to have originated this form of the subject in netsuke, it was widely copied by local craftsmen, as well as those from somewhat further afield.[10] Yet another branch of *netsukeshi* in the area adopted the character 'masa', as exemplified by Sawaki Masakazu (*c.* 1839–91). Since Masakazu had an elder brother Masatoshi, it is highly likely that he was a pupil of Tadatoshi, as he adopted the character 'toshi'.[11] Kagetoshi (active early 19th century) is yet another *netsukeshi* who worked in the Nagoya region, although he is thought to have been born in Kyoto. He is particularly well known for his intricate carvings (Plates 55 and 56), often of landscapes, that are deeply undercut.

Another small, but distinctive regional group was that from Yamada, Ise province, originating with Masanao I (1815–90), who studied carving with Ittan. The family consisted of Masanao's son and pupil, Masakatsu (d. 1899), as well as four other Masanaos and various pupils who used the same '*masa*' character. Since Masakatsu was in poor health, however, his output was small. He is particularly associated with studies of rat and young, in meticulous detail (Plate 102). Successive generations carved almost exclusively in wood, especially boxwood, in a detailed, naturalistic manner. Although the range of subjects is wide, the Masanao family specialized in animals, many compositions being reworked by subsequent generations; favourite themes were the coiled rat (Plate 3), toad on a broken bucket (Plate 103) and toad on a sandal (Plate 39). It is interesting that the current and fifth master of the Masanao line, Masami (1937–), has not only produced her own versions of the toad and sandal, but has also brought it up-to-date with a variant consisting of a sleeping cat in a lace-up shoe.

Tanaka Minkō (1735–1816), also mentioned in the *Sōken kishō*, was the founder of a small line of *netsukeshi* in Tsu, also in Ise province. Minkō was originally a carver of Buddhist household shrines who was taken into the service of the Tōdō clan. He moved to Tsu and subsequently took up netsuke carving, working in a wide range of woods, especially boxwood. Although his output is thought to have been prolific, he was widely copied, even during his own lifetime. He is known to have produced several versions of a subject illustrated in the *Sōken kishō*, although it is attributed there to another craftsman, Ogasawara Issai from Wakayama. Since the illustration in the *Sōken kishō* is annotated with the characters *haiyū* (actor), it is possible that the subject refers to a play, *Kanadehon Chūshingura*, which was first performed in 1748 and was highly popular at the time.[12] Since the figure portrayed in the *Sōken kishō* appears to be lying in wait, wearing a straw cape and carrying a gun, he can possibly be identified as one of the characters, Hayano Kanpei, a warrior who adopted a simple, rustic lifestyle as a disguise (Plate 104). Minko had two pupils or followers of note, Kokei (late 18th century) and Tōmin (late 18th – early 19th century), who worked in similar styles. Master and pupils all produced distinctive seated tigers; they are invariably portrayed with the head turned back to the left, the mouth open, and with comparatively large paws, while the long tail is curled round the body (Plate 105).

104 Disguised warrior lying in wait. Wood. Signed 'drawn by Tanaka Minkō' with a *kaō*. 1775–1825. L. 5.6cm.
A856–1910. Salting Bequest.

105 Tiger. Wood, eyes inlaid in mother-of-pearl and another material. Signed 'Tōmin'. 1775–1825. H. 3.5cm.
A.939–1910. Salting Bequest.

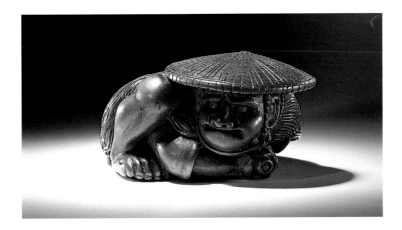

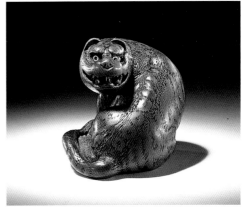

Takayama, situated in Hida province, an area with a long-established tradition of wood carving, is surrounded by mountains and forests in which the yew tree grows abundantly. This was the home of Matsuda Sukenaga (1800–71), a self-taught but gifted carver, who felt the need to acquire special skills to progress in his craft. For this reason he went to Edo, where he studied under Hirata Suketomo (1810–47), who came from Takayama but moved to Edo as a young man and died when only 38. As Sukenaga already possessed the basic skills and was ten years older than Suketomo, he went back to Takayama before long, although he frequently returned to Edo. It was undoubtedly from Suketomo that Sukenaga acquired the first part of his name. Two lines of carvers developed from Suketomo and Sukenaga, the Tsuda and Eguro lines respectively, with members of both making use of the same 'suke' character.[13] Sukenaga was the originator of ichii ittōbori ('carving yew with a single knife stroke'), which became the hallmark of carvings from Hida province (Plate 23). The technique results in angular cuts with minimal detail, in direct contrast to the netsuke with meticulous and detailed carving that were popular elsewhere during the nineteenth century. Sukenaga was undoubtedly influenced by sculpture of the monk Enkū (1632–1705), who made use of the earlier natabori ('hatchet carving') technique, which resulted in an axe-hewn style.[14] Sukenaga travelled widely and, on a visit to Nara, saw Nara ningyō ('Nara dolls') that were carved in a similar chisel-cut manner. He regretted the fact that, through painting the surface, the raw impact of the carving was lost.[15] As a result, he is said to have come up with the idea of using yew, which has both light and dark natural stripes and thereby provides colour without paint.

Naitō Toyomasa (1773–1856), a resident of Sasayama, was largely responsible for the fame of netsuke in Tanba province. He established a workshop specializing in netsuke (Plate 71), but also producing inrō and large-scale sculptures. The workshop comprised a number of assistants, including his son Toyomasa II (1811–83), also known as Hidari Toyomasa ('left [-handed?] Toyomasa'),[16] and his pupil Toyokazu. In 1835 he was appointed official carver to the Lord of Sasayama, although he was also commissioned to carry out work for others. Since such work involved the submission of detailed information and drawings for approval, the Naitō family have in their possession an annotated drawing of an inrō, ojime and netsuke for the Lord of Sasayama.[17] Toyomasa worked almost entirely in wood, which was often stained; many of his works reveal a distinctive style of openwork carving that incorporates swirling lines, either in the form of clouds or sea (Plate 17). On the basis of the inscriptions, there are at least three netsuke in existence that were a collaboration between father and son, two in 1841 and one in 1845. Since these were made not long after Toyomasa was appointed official carver to the Sasayama clan, it is likely that the purpose was to promote Toyomasa's son in the eyes of the patron.

The most distinctive netsuke to have been produced outside the main urban centres were undoubtedly those from Iwami province. Strictly speaking, 'Iwami' netsuke include similar examples from adjoining areas, as well as those made elsewhere in styles and materials characteristic of the province. Iwami, which consists of a large part of present-day Shimane prefecture, was situated in the south-western tip of the main island of Honshū. It had a long coastline to the north-west, while a large percentage of its total area consisted of mountainous terrain or woodland. The geographical isolation

and poverty of the region played a formative role in the development of its netsuke, both in terms of materials and subject-matter. Imported ivory, for example, which was widely used in more central, affluent parts of Japan, was less common, while tusks from the wild boar that roamed widely there, were frequently used. Other common materials, many of which were local, included *umimatsu* and marine ivory. For their subject-matter, the *netsukeshi* of Iwami tended to concentrate on local plants and lesser creatures, such as spiders, centipedes and frogs, compared to the tigers and oxen more readily produced in central Japan. Designs of this type were often carved in a type of low relief (*ukibori*) on soft materials, such as wood, by compressing the parts to be raised with a round-pointed instrument. The surrounding area was then planed down to the compacted parts, before being soaked in water for a short time. As a result, the compressed parts took in water and stood up proudly. This technique was often used for many of the signatures, the texture of frog's skin or the veins of a leaf. A similar effect was more rarely achieved in ivory and boar's tusk by using acids and wax resist.

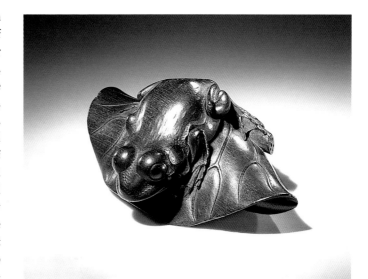

106 Frog on a lotus leaf. Ebony. Signed 'carved by Namie Tomiharu of Iwami province'. 18th century. L. 6.5cm.
A.982–1910. Salting Bequest.

Another characteristic of Iwami netsuke that sets them apart is the widespread use of long inscriptions, often using somewhat obscure wording in fine *kebori* ('hair carving'). These not only include the name of the craftsman, but frequently also the date and place of manufacture, along with a poem. Iwami netsuke may have been produced in a cultural backwater, but their signatures raise them to a degree of sophistication not found on netsuke made elsewhere. According to the inscriptions, there were five main *netsukeshi* who worked in Iwami, with Tomiharu as the leading exponent. Tomiharu (1733–1810)[18] was born at Tamatsukuri in Izumo province, east of Iwami. At the age of 13, he entered the Chōeiji temple, Iishi district, Iwami, as a novice, leaving there two examples of his sculptural work.[19] After a few years at the temple, the accounts of his life differ; he is reputed to have left either for Edo or for Kyoto, to train as a sculptor. He also moved around Iwami and Izumo, where he began to receive the patronage of a wealthy Iwami merchant, Yokota Gozaemon of the Okitaya. Tomiharu is thought to have had one son and two daughters, one of whom, Bunshō, was born in 1764 (Plate 30). At some point, Tomiharu established the Seiyōdō studio where he and his pupils carved netsuke. Apart from his boar's tusk netsuke, one of his favourite subjects was that of the tree-frog on a branch or leaf (Plate 106).

Tomiharu's daughter, Bunshō (1764–1838), was undoubtedly the most talented of his followers. She was also one of the few recorded female *netsukeshi*; the *Sōken kishō* lists only one, Nakayama Yamatojo from Edo. Bunshō frequently alluded to her gender by either signing her work as 'the daughter of Tomiharu' or 'Bunshōjo', '*jo*' being a suffix for 'woman'. Although Reikichi records that she was single and drank too much, there is now evidence to suggest that she not only married, but that it was her husband who was an alcoholic.[20] Her work is very similar to that of her father, except that she regularly

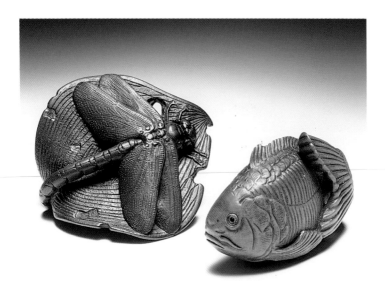

107 Dragonfly on a bog arum leaf. Boxwood, dyed and stained. Signed 'MJW' (Michael Webb). November 1987. L. 5.2cm.
FE.156–2002.

Golden carp. Boxwood, eyes inlaid with gold. Signed 'MJW' and 'ALW' (Alexandra Louise Webb, a jeweller) for the eyes. August–September 1985. Also engraved with entwined G & C (George & Cornelia Wingfield-Digby, for whose Golden Wedding this was carved). L. 4.7cm.
FE.155–2002.

used elephant ivory. In addition, her netsuke are often more ornate than his, her boar tusks being typically decorated on the reverse with ferns. Gansui (1809–48) was undoubtedly Bunshō's pupil; rather than being her son, as was traditionally believed, it now seems probable that he was her nephew whom she adopted at birth. His work is very like that of Bunshō.

Kanman (1793–1859) may well be one of the least well-known Iwami carvers, but he was certainly one of the most gifted. Although his work bears many similarities to those of his Iwami predecessors, he does not appear to have been a pupil of either Tomiharu or Bunshō; indeed, he is more innovative and individualistic. He was the only craftsman, moreover, to have made widespread use of *umimatsu*. His boar's tusk netsuke also display more detailed decoration covering a larger surface area, frequently depicting a dragon that may extend over more than one plane. Another highly gifted *netsukeshi*, Gohō (active 1801–11), also known as Mitani Kō tsū (or Kimimichi), lived south of Iwami in Aki province. He is particularly noted for his ivory netsuke of a cluster of marine creatures, including numerous shells and crabs, as well as meticulous boxwood frogs.

Today, netsuke carving has developed beyond all expectations, with a large number of Japanese *netsukeshi* producing high-quality, inspirational works; a few should be mentioned, namely Saitō Bishū (1943–), Sakai Masami (1937–), Nakamura Masatoshi (1915–2001) and Komada Ryūshi (1934–). The formation of the International Netsuke Carvers' Association in 1989, moreover, was an acknowledgement of the fact that netsuke carving was no longer the sole preserve of the Japanese. Indeed, without feeling tied to the constraints and traditions of netsuke, Western artists have often brought a new dimension to the art in the twentieth, and now, twenty-first century. Here, in Great Britain, there is already a well-established tradition, which includes Michael Birch (1926–), Michael Webb (1934–) (Plate 107) and Guy Shaw (1957–), while the US could be represented by David Carlin (1944–), and the Australian continent by the British-born Susan Wraight (1955–).

Throughout the Edo period, netsuke were purchased by a large cross-section of the male population, from the emperor and *shōgun* down. The majority of netsuke were purchased from shops, whether as new or antique items. Not only does the novelist, Saikaku, describe a netsuke on display in the window of what was obviously a junk shop (page 74), but depictions of two such shops show various *sagemono* and other small items hanging on display.[21] Netsuke could be purchased new from various shops that sold *sagemono*, especially tobacco accessories; such establishments were known as *fukuromonoya* ('pouch-thing shop'). Netsuke could also be bought from shops that handled wood and ivory carvings.[22] It is highly likely that the owners of such shops also dealt directly with *netsukeshi* over special commissions from customers. The price of

netsuke varied, but most *netsukeshi* eked out a meagre existence. However, with the popularity of netsuke in the West during the latter part of the nineteenth century, some of them began to command reasonably high prices. An ivory netsuke of a crane by Masatsugu, for example, formerly in the Frances and Raymond Bushell collection and currently in the Los Angeles County Museum of Art, is still accompanied by the original bill of sale for this piece, which was commissioned by a Seishichi-san, presumably in the second half of the nineteenth century.[23] The bill quotes the agreed price as 3 *ryō* and 3 *bu*, a substantial amount equivalent to the cost of one small house with land.[24] After three months, the outstanding bill had not been settled, requiring Masatsugu to send a tactful reminder, which was immediately honoured. According to undated correspondence between Hōjitsu (d. 1872) and his agent, Hishiya Risuke, the *netsukeshi* asks the even higher price of 6 *ryō* for a netsuke of a *rakan* (Buddhist holy man), made when Hōjitsu was 72.[25]

1 Arakawa (1983) p. 197.

2 Bibliographies of *netsukeshi* can be found in Ueda (1943) and Bushell (1961), Davey (1974) and Lazarnick (1976 and 1982), though these are all now out of date.

3 Watanabe (1999)2, p. 21.

4 For examples of a few of his paintings, see Watanabe (1999)2, pp. 20–21.

5 Reikichi (1961), p. 273.

6 Shimatani (1999)1, pp. 44–5.

7 Shimatani (1999)2, pp. 35–6.

8 Shimatani (1999)1, p. 29.

9 Akatsu (1996), p. 26.

10 For a similar example in the V&A from Tsu, which was some 40 miles from Nagoya, see Earle (1980), pl. 36.

11 Akatsu (1997), pp. 31–2.

12 Earle (2001), pp. 192–3.

13 Ouwehand (1971), pp. 39–40.

14 For examples, see Watson (1981), pls 276a –276b.

15 Reikichi (1961), p. 294.

16 There is some difference of opinion over the reading of Toyomasa II's name, which has traditionally been read as Toyoyasu. See Watanabe (1999), p. 9 and Ichimichi (2001) pp. 21–4.

17 Ichimichi (2000), Fig. 4.

18 There is some discrepancy over his birth date. See Earle (2000), p. 11.

19 Earle (2000), p. 12.

20 Burditt (1999), p. 29.

21 See Pekarik (1980) fig.41 and Jirka-Schmitz (2000) fig. 4.

22 Jirka-Schmitz (2000), p. 39.

23 Atchley (1992), pp. 12–13.

24 This information was provided by Kengo Sekido in Atchley 1992, footnote 1.

25 Schmitz (2000), p.41, quoting from Sekido (1999), p. 32 and p. 36, fig. 3.

8 | Collecting Netsuke

In addition to their primary function, netsuke became the focus of decorative attention from an early date, while also often bringing their owner much pleasure and enjoyment. Depending on his financial circumstances, an individual is likely to have possessed a number of netsuke, so that he could select the most appropriate for the occasion, time of year and his personal mood, as well as the size and type of *sagemono* it was to suspend. Today, the extensive *sagemono* and netsuke collection of Matsura Seizan (1760–1841), daimyō of Hirado, is well known through the detailed descriptions in his diaries.[1] There must have been many others whose collections went unrecorded.

During the second half of the nineteenth century, the status of netsuke underwent a drastic change. This was largely because of a chain of events initiated by the arrival of Commodore Matthew Perry and his American fleet of ships off the coast of Japan in 1853. The following year, the first of many trade agreements were concluded, while full commercial treaties with the leading Western nations were not negotiated until 1858. After a period of prolonged national seclusion, external pressure exacerbated internal unrest, culminating in the downfall of the Tokugawa regime and the restoration of the Meiji Emperor in 1868. This not only resulted in profound political, economic and social changes, but also opened the floodgates to Western influence. Although the adoption of Western dress was not nearly as sudden or as widespread as is often believed, it was undoubtedly seen as modern and progressive, heralding the decline of the kimono. The Western suit, moreover, included pockets. The netsuke, as well as the *sagemono* in general, were no longer needed, so that ultimately they came to be considered old-fashioned curios. It had also become fashionable at this time to attach tobacco accessories to a pipe and pipe-case thrust through the sash, thereby obviating the need for a netsuke. In addition, the introduction of cigarettes meant that it was no longer necessary to carry tobacco accessories.

Since netsuke were traditionally regarded as functional rather than art objects, once they had outlived their main purpose, they became dispensable items. This coincided with the opening of Japan and the enormous interest in Japanese artefacts in the West, and soon it became apparent that netsuke were much in demand. There, however, netsuke served no practical purpose and were seen as works of art; their use or context seemed irrelevant. Marcus Huish, a typical voice of the time, wrote in 1892: 'There is no section of Japanese Art which succeeds in attracting the attention of everybody who is brought into contact with it, so much as that which is comprised under the heading of netsuké carvings'.[2]

While Japan was still a 'closed' country during the Edo period, netsuke are known to have reached the West sporadically. Around 1780, for example, a small collection of

Opposite: Detail from Plate 108.

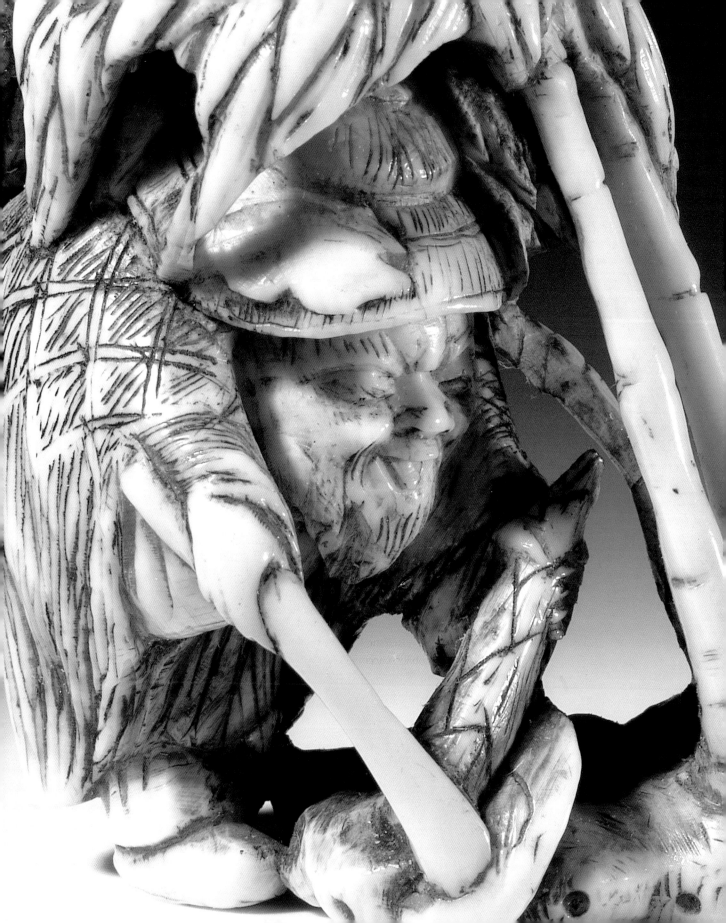

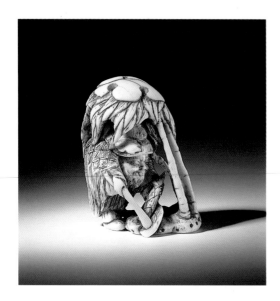

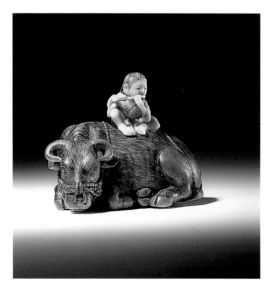

108 Mōsō cutting bamboo shoots. Ivory. 19th century. H. 3.8cm.
A.787–1910. Salting Bequest.

109 Ox and boy playing the flute. Boxwood and ivory. Signed 'Genryōsai'. 1800–50. L. 4.1cm.
372–1904. Dresden Bequest.

netsuke was brought to Holland by Isaac Titsingh, the Dutch Opperhoofd (chief agent) on Dejima.[3] Similarly in 1830, Von Siebold, the German naturalist working for the Dutch mission, is known to have brought to Holland roughly six netsuke by Ottoman, a carver from the province of Chikuzen. Despite the fact that they were presented to the Ethnographic Museum in Leiden, they are thought to have been lost during the Second World War. There is also an interesting story concerning a netsuke and an individual in Matthew Perry's entourage.[4] One of the Japanese receiving party, Kōzaburō Mikawaya, wore a tobacco pouch with a mask netsuke, with which the American was greatly taken. Although Kōzaburō finally agreed to part with it, he was imprisoned almost immediately for trading prior to the conclusion of any agreement. He was subsequently released and, although versions of the story differ in detail, Kō zaburō went on to establish the Sankō trading company in Tokyo, which specialized in netsuke and other art objects.

In 1878 Sir Rutherford Alcock astutely wrote: 'In Japan the sudden demand of foreigners has carried out of the country all that was best worth possessing in nétsuzkés...'[5] This is indeed borne out by the facts, with enormous numbers of netsuke leaving Japan and forming the basis of many Western collections, especially in England, France and Germany. Among the most well-known collections in Europe at this time were those of Albert Brockhaus, Louis Gonse, Michael Tomkinson and Seymour Trower, with W.L. Behrens amassing the staggering total of 5639 netsuke, many of high quality. In addition, A.W. Franks, who joined the staff of the British Museum in 1851, had an extensive collection of approximately 1,400 netsuke; although he originally lent these to the Museum, they subsequently entered their permanent holdings.[6] It is also evident that early collections of netsuke sometimes exerted a direct influence over Western artists. In particular, the heyday of the workshop of the Russian goldsmith Peter Carl Fabergé (1846–1920) coincided with significant numbers of netsuke reaching the West. An important output of the workshop consisted of intricately carved miniature animals in agate, nephrite, rock crystal and lapis lazuli, a far cry from the widespread use of wood and ivory among Japanese examples. While the general debt to netsuke is unmistakable, the distinctive subjects and poses of certain Fabergé animals even have identical netsuke counterparts.[7]

The V&A's collection of netsuke comprises roughly 1,400 items, the approximation arising from whether some items may be classified as *okimono* or netsuke. The collection was largely built up through the gifts and bequests of numerous individuals, the most important being that of George Salting in 1910, which formed the backbone of the V&A's netsuke (Plate 108). The other main benefactors of significance, in chronological order, were Edmond Dresden (1904) (Plate 109), Robert Taylor Pritchett (1907) (Plate 32), Mrs Gerard Fox (1915) (Plate 110), Henry Louis Florence (1917), Mrs Wheatley (1918)

(Plate 22), Clarke-Thornhill (1919–1920) (Plate 95), William Cleverly and the misses Alexander (1916), Rose Shipman (1952) (Plate 111), Miss A. Nash (1953) and Adèle Helena Schwaiger (1995) (Plate 87). The Museum's collection, which is generally of high quality and comprises approximately twice as many netsuke made of wood than ivory, is reasonably comprehensive. There are, however, certain gaps. In terms of netsuke type, for example, it does not possess a single *sashi* or *obihasami* (although these are, in any case, among the least numerous). Until recently, moreover, examples from the twentieth century were virtually non-existent in the collection. A few years ago it was able to purchase an example by the lacquerer Unryū an (1952–) (Plate 54), who has worked unstintingly to rediscover lost techniques of the past. In addition, just before going to press, we have also been most fortunate to acquire by gift two netsuke by the British carver, Michael Webb (Plate 107).

As the first generation of netsuke collectors died and their collections were dispersed, their objects in turn entered new collections, thus creating a further generation of collectors. When netsuke first reached the West, they could be bought comparatively cheaply; at a Christie's sale of 1864, 12 lots of four netsuke each fetched between one and five pounds.[8] Before long, however, prices began to rise steadily, with collectors and dealers paying staggering sums to secure their purchase in more recent years.[9] In 1984 the situation was admirably summed up by Bernard Hurtig:

'Great changes have transpired in the world of netsuke in the past fifty years. Netsuke, prior to 1967, were relatively a minor art, but in the last fourteen years, collectors have seen a major recognition of their favorite collectible. Although prices have increased dramatically over the last few years, to this day, Japanese netsuke remain one of the most undervalued of all art forms… A netsuke, while not always original in design, is always a hand-sculptured work of art…'[10]

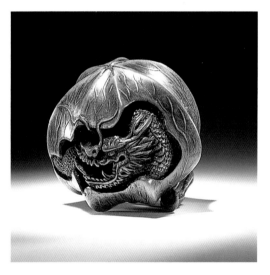

110 Cock pecking at a radish. Ivory. Signed 'Shūōsai', 1800–50. H. 4.13cm.
A.63–1915. Fox Gift.

111 Dragon and Chinese lantern. Wood. Signed 'Toyokazu', 1850–1900. H. 4cm.
A.54–1952. Shipman Gift.

1 Matsura (1978) and Pekarik (1980), pp. 124–6.

2 Huish (1892), p. 206.

3 De Perthuis (1983), p. 21.

4 Okada, pp.32–41 and de Perthuis (1983) p. 21.

5 Alcock (1878), p. 206.

6 Smith (1997), p. 268.

7 Snowman (1979), p. 65.

8 De Perthuis (1983), pp. 22–3.

9 In a series of articles, de Perthuis (1983–1984) presented a detailed summary of the market and prices up until 1984.

10 De Perthuis (1984)1, p. 17.

Chronologies

Acknowledgements

Periods in Japanese History Mentioned in
the Text

Jōmon Period	12,500 – 300 BC
Heian Period	794 – 1185
Kamakura Period	1185 – 1333
Edo Period	1615 – 1868
Kan'ei era	1624 – 1644
Kyōhō era	1716 – 1736
Tenmei era	1781 – 1789
Meiji Period	1868 – 1912

Periods in Chinese History Mentioned in
the Text

Eastern Zhou Dynasty	770 – 221 BC
Warring States Period	475 – 221 BC
Han Dynasty	206 BC – AD 221
Tang Dynasty	618 – 906
Song Dynasty	960 – 1279
Yuan Dynasty	1279 – 1368
Ming Dynasty	1368 – 1644
Qing Period	1644 – 1911

Periods in Korean History Mentioned in
the Text

Silla Kingdom	57 BC – AD 668
Three Kingdoms Period	57 BC – AD 668
Unified Silla Period	668 – 918

I am deeply indebted to Joe Earle, colleague and former Keeper of the Far Eastern Department of the V&A, for all his previous work on the collection of netsuke. In particular, for his two published works on the V&A's collection, an article (Earle 1978) and a book (Earle 1980), which has long been out of print. He also made the selection and provided transcriptions of the signatures for a microfiche of the collection (Victoria & Albert Museum 1985), which has proved invaluable. At all times, he has freely shared his knowledge of the collection and of netsuke in general.

I am also extremely grateful to Heinz and Else Kress for help in innumerable ways. In particular, a short research trip to their home in Finland gave me the opportunity to make free use of their extensive library, database and archives in genial surroundings. As always, an important part of their hospitality involved a free discussion of ideas on netsuke and related matters, which proved extremely constructive. I am continuously grateful for the speed and good humour with which they supply or check information from material in their archives. They have also been most generous in allowing me to use photographic material from their archives.

It was an enormous privilege to have been taken by Masanori Watanabe to meet Masatoshi Nakamura and his daughter at their home and workshop in Tokyo before they both passed away. Masatoshi not only freely answered my questions, but the visit also gave me an insight into the working practices of a *netsukeshi*.

I would also like to convey my enormous thanks to Joseph Kurstin for allowing me to spend time examining his superb collection of netsuke. By one of those fortuitous quirks of fate, the V&A has been most fortunate to acquire the gift of two exquisite examples of work by the contemporary British netsuke carver, Michael Webb. The gifts from Susan and John Moor, as well as Webb himself, were just in time to be included in the book. In the course of carrying out research for this book, many institutions and individuals have been most generous in their help, both great and small. In particular John Carpenter, as well as Craig Clunas, Kumiko Doi, Robert Fleischel, Stephanie Fong, Yukiko Kashihara, Makiko Komada, Natsuo Miyashita, Hayato Ohgi and Yukari Yoshida.

I would also like to express my sincere thanks to individuals and museums who most generously supplied illustrations of netsuke and related material, or gave permission to use them. These include Robyn Buntin, Jim Marinaccio, Naga Antiques, Ltd. NYC, MOA Art Museum, Atami, Japan, ROM, Toronto, Canada, and the Seikadō Bunko Art Museum, Tokyo, Japan.

Since netsuke are highly visual, the illustrations of this book are an essential and integral part of it. I am deeply indebted, therefore, to Ian Thomas and Richard Davis of the Photographic Studio, for their superb photographs of the netsuke and related material in the V&A, all of which have involved new photography. In addition, the photography programme was expertly and efficiently organized by Liz Wilkinson of the Far Eastern Section, Asian Department. All other members of the Far Eastern Section contributed to the work of this book in one way or another. In particular Greg Irvine and Verity Wilson contributed specific information, while Rupert Faulkner most kindly commented on a draft of the text. I am also extremely grateful to Mary Butler, Ariane Bankes and Monica Woods of V&A Publications for seeing the first edition through to publication. Finally, I would like to express my gratitude to Edmund de Waal for writing the forward.

Glossary

chōnin townspeople

daimyō feudal lord

Fujin God of Wind, often accompanying Raijin, the God of Thunder

guri ('bent ring') layers of different-coloured lacquer carved with distinctive scrolls in V-shaped cuts to reveal the sequence of layers

hako netsuke netsuke in box form

Hannya Nō theatre character representing vengeful, female jealousy

himotōshi channels in netsuke, *inrō*, *ojime* and *sagemono*, through which the cord is threaded

hiramakie ('flat sprinkled picture') metal or coloured powders sprinkled on to a lacquer ground before it has hardened

hirazōgan ('flat inlay') metal technique whereby the inlay is flat

hiuchi bako mechanical flintlock tinder-box

hiuchi bukuro receptacle for holding fire-making implements

hōkkyo ('bridge of the law') Buddhist title awarded to high-ranking artists

hōo mythical bird, similar to a phoenix

ittōbori ('carving with a single knife stroke') type of carving with angular cuts and minimal detail

inrō tiered, decorative container worn suspended from a sash from around the end of the sixteenth century onwards

Jō an old man who, together with Uba, embodies conjugal fidelity

Kabuki popular urban theatre originating in the seventeenth century

kagami netsuke composed of a flattened, circular bowl, usually of ivory or wood, into which a decorated metal disc fits

kagamibuta ('mirror lid') see *kagami* netsuke

katakiribori ('shape-cut engraving') metalwork technique in which the surface is carved to imitate the effects of brushwork. The carved groove has a V-shaped cross-section with one side longer and shallower than the other

kaō personal cypher or artistic monogram

kara netsuke seminal netsuke of a thick ring with a narrow opening

katabori ('shape carving') netsuke carved in the round

kebori ('hairline engraving') metalwork technique that leaves a V-shaped groove

kimma painting and engraving lacquer technique that originated in Thailand

kimono traditional Japanese garment for men and women

kinchaku money pouch

kirin mythical quadruped, usually a hybrid of real and imaginary features

kiseru distinctive Japanese pipe with tiny metal bowl for smoking tobacco

kiseruzutsu pipe-case

makie ('sprinkled picture') generic term for a number of related lacquer techniques in which metal or coloured powders are sprinkled on to wet lacquer

manjū netsuke that resembles a rounded sweet dumpling filled with bean paste, in one or two parts

mokugyo Buddhist wooden drum or gong

Mōsō as one of the 24 examples of Chinese filial piety Mōsō, at his mother's request, set out to find bamboo shoots in the depth of winter

Negoro-nuri ('Negoro lacquer') lacquer technique whereby red lacquer is applied over black and the surface rubbed through to the underlying layer in irregular patches

netsuke ('root attach') toggle used to suspend the *inrō* and other items of *sagemono* from the sash

netsukeshi craftsman specializing in making netsuke

Nō classical drama, which makes use of masks

obi sash

obihasami ('sash claws') type of netsuke of flattened form that lies predominantly behind the sash, comprising curved projections at one end that hook over the sash

obiguruma ('sash wheel') seminal netsuke of a thin ring with a large opening

ojime bead for tightening the cord of an *inrō* or other items of *sagemono*

Okame Goddess of Mirth, also known as Uzume

okimono decorative carving usually serving no practical function

oni demon

Raijin God of Thunder (see Fujin)

rui scrolls 'cloud collar' scrolls

ryūsa type of *manjū* or *kagami* netsuke that is carved in openwork

sagemono ('hanging things') collective term for pouches and containers worn suspended from the sash

sashi long, thin type of netsuke that was worn inserted between the sash and kimono, with only the topmost, decorated part being visible

sennin Chinese Daoist immortals

sentoku alloy of copper and tin, resulting in shades of gold colour

shakudō alloy of copper with a small amount of gold resulting in colours ranging from blue, through purple to black

shamisen Japanese stringed instrument

shibuichi ('one part in four') alloy of copper with about one quarter silver, resulting in shades of grey

shishi mythical lion-dog of Chinese origin

shishiaibori ('complexion carving') carving in sunken relief, so that the highest parts of the design are level with the rim of the netsuke

shōgun military governor of Japan ruling in the name of the emperor

surimono ('printed thing') privately commissioned print, usually elaborately printed

tabakoire tobacco pouch worn suspended from the sash

takamakie ('high sprinkled picture') lacquer technique that is similar to *hiramakie*, but parts of the design are raised by clay or charcoal powder

takazōgan ('high inlay') metal technique whereby the inlay is in high relief

tengu mythical, hybrid creature with some bird and some human features, usually wings and a long nose

togidashie ('brought out by polishing') lacquer technique whereby a design is covered completely with lacquer and polished until the design reappears flush with the ground

tonkotsu tobacco box worn suspended from the sash

ukibori type of carving in low relief whereby the parts to be raised are compressed with a round-pointed instrument and the surrounding area is then planed down before being soaked in water

Ukiyoe paintings, prints and book illustrations of the 'floating world' of urban pleasures, dating from the seventeenth to the nineteenth centuries

umimatsu 'sea pine' not wood but a form of black coral, known in the West as litophyte

yatate portable writing set carried from the sash

Select Bibliography

In view of the large number of works on netsuke, catalogues of individual collections have been avoided unless they make a significant or particular contribution to the subject.

Addiss, Stephen (ed.), *Japanese Ghosts and Demons* (New York in association with the Spencer Museum of Art, University of Kansas, exhibition catalogue, 1985)

Akatsu Kentaro, 'Ikkan and His Family', *International Netsuke Society Journal* (Summer 1996), vol. 16, no. 2, pp. 25–9

Akatsu Kentaro, 'Nagoya School Carvers; Genealogical Update', *International Netsuke Society Journal* (Summer 1997), vol. 17, no. 2, pp. 30–2

Alcock, Sir Rutherford, *Art and Art Industries in Japan* (London, Virtue and Co. Ltd, 1878)

Arakawa Hirokazu (ed.), *Inrō to netsuke, Nihon no bijutsu* (Tokyo, 1982), no. 195

Arakawa Hirokazu, *The Gō Collection of Netsuke, Tokyo National Museum* (Tokyo, New York and San Francisco, Kodansha International, 1983)

Arakawa Hirokazu, 'Inrō to netsuke no hassei ni taisuru ikkōsatsu', *Museum*, no. 395 (February 1984), pp. 4–16

Arakawa Hirokazu (ed.), *Netsuke: takumi to share* (Kyoto, Tankosha, 1995)

Atchley, Virginia and Neil Davey, *The Virginia Atchley Collection of Japanese Miniature Art* (Chicago, 2005)

Atchley, Virginia, 'Kaigyokusai – An appreciation', *Netsuke Kenkyukai Study Journal* (Winter 1992), vol. 12, no. 4, pp. 10–21

Treasured Miniatures; Contemporary Netsuke (British Museum, Los Angeles County Museum of Art, exhibition catalogue, 1994)

Brown, Ken, 'Why Art Historians Don't Study Netsuke and Why They Should', *International Netsuke Society Journal* (Spring 1997), vol. 17, no. 1, pp. 8–24

Burditt, David, 'Introduction to Iwami Carvers and the Work of Tomiharu', *International Netsuke Society Journal* (Fall 1998), vol. 18, no. 3, pp. 30–8

Burditt, David, 'Iwami Carvers: the Work of Bunshojo', *International Netsuke Society Journal* (Spring 1999), vol. 19, no. 1, pp. 29–40

Burditt, David, 'Iwami Carvers: the Work of Gansui and Goho', *International Netsuke Society Journal* (Fall 1999), vol. 19, no. 3, pp. 34–46

Burditt, David, 'The Iwami Carvers: Kanman', *International Netsuke Society Journal* (Spring 2000), vol. 20, no. 1, pp. 47–55

Burditt, David, 'Iwami: Pupils of the Seiyodo School', *International Netsuke Society Journal* (Winter 2000), vol. 20, no. 4, pp. 38–45

Bushell, Raymond (adapted from the Japanese by), *The Netsuke Handbook of Ueda Reikichi* (Rutland, Vermont: Tokyo, Japan, Charles E. Tuttle Company, 1961)

Bushell, Raymond, *Netsuke Familiar and Unfamiliar: New Principles for Collecting* (New York, Tokyo Weatherhill, 1975)

Bushell, Raymond, *Collectors' Netsuke* (New York, Tokyo, 1971)

Bushell, Raymond, *Netsuke Masks* (Tokyo, New York and San Francisco, Kodansha International Ltd, 1985)

Cammann, Schuyler, *Substance and Symbol in Chinese Toggles: Chinese Belt Toggles from the C.F. Bieber Collection* (Philadelphia, University of Philadelphia Press, 1962)

Camper Titsingh, Mary, 'The 1893 Auction Catalog of Dr. J.D.C. Titsingh's Collection of Japanese Art', *Netsuke Kenkyukai Study Journal* (Winter 1989), vol. 9, no. 4, pp. 31–6

Caygill, Marjorie and John Cherry (ed.), *A.W. Franks; Nineteenth century Collecting and The British Museum* (London, British Museum Press, 1997)

Chappell, Sharen Thane, 'The Proud Tradition of Hida-Takayama Wood Carvers', *Netsuke Kenkyukai Study Journal* (December 1982), vol. 2, no. 4, pp. 17–27

Committee of the Ukiyoe Encyclopedia (eds), *Genshoku ukiyoe daihyaku jiten* (Tokyo, Taishūkan Shoten Corporation, 1981)

Coullery, Marie-Thérèse & Martin S. Newstead, *The Baur Collection, Geneva: Netsuke (Selected Pieces)* (Geneva 1977)

Davey, Neil K., *Netsuke: A Comprehensive Study Based on the M.T. Hindson Collection* (London, Faber & Faber Ltd. in association with Sotheby Parke Bernet Publications, 1974)

Dickinson, Gary, and Linda Wrigglesworth, *Imperial Wardrobe* (London, Bamboo Publishing Ltd, 1990)

Ducros, Alain, 'In Search of Tametaka', *Netsuke Kenkyukai Study Journal* (Winter 1986), vol. 6, no. 4, pp. 15–17

Ducros, Alain, *Netsuke & Sagemono 2* (Granges-les-Valence, 1987)

Ducros, Alain, 'Materials used in Netsuke', *Netsuke Kenkyukai Study Journal* (Fall 1989), vol. 9, no. 3, pp. 36–41

Ducros, Alain, 'Tametaka', *Bulletin Association Franco-Japonaise*, no. 24 (April 1989), pp. 19–24

Ducros, Alain, 'Toyomasa', *Bulletin Association Franco-Japonaise*, no. 41 (July 1993), pp. 15–22

Earle, J.V., 'Victoria and Albert Museum', *Journal of the International Netsuke Collectors Society* (March, 1978) vol. 5, no. 4, pp. 27–37

Earle, Joe, *An Introduction to Netsuke: Victoria and Albert Museum* (London, The Compton Press Ltd and Pitman House Ltd, 1980)

Earle, Joe, 'Netsuke – An International Art', *The Robert S. Huthart Collection of Non-Iwami Netsuke* (Barry Davies Oriental Art Ltd, London, exhibition catalogue, 1998)

Earle, Joe (Introduction & compiled by), 'The Netsuke Carvers of Iwami Province', *The Robert S. Huthart Collection of Iwami Netsuke*, 2 vols, (Hong Kong, privately printed, 2000)

Earle, Joe, *Fantasy and Reality in Japanese Miniature Sculpture* (Boston, Museum of Fine Arts, 2001)

Eijer, Dieuwke, *Kagamibuta: Mirrors of Japanese Life and Legend* (Leiden and Geneva, Heinz Kaempfer Fund and the Baur Collection, 1994)

Forrer, Matthi, 'Netsuke: a historical approach', *Apollo* (April 1999), vol. CXLIX, no. 445, pp. 54–8

Garrett, Valery *A Collector's Guide to Chinese Dress Accessories* (Singapore, Times Editions, 1997)

Gillman, Derek, 'Ming and Qing ivories: figure carving', Watson, William (ed.), *Chinese Ivories from the Shang to the Qing* (The British Museum, London, exhibition organized by the Oriental Ceramic Society, 1984)

Gluckman, Dale Carolyn and Sharon Sadako Takeda, *When Art Became Fashion: Kosode in Edo-Period Japan* (Los Angeles County Museum, Los Angeles, exhibition catalogue, 1992)

Gombrich, E.H., *The Story of Art* (London, Phaidon Press, 1997)

Goodall, Hollis, Virginia G. Atchley et al, *The Raymond and Frances Bushell Collection of Netsuke: A Legacy at the Los Angeles County Museum of Art* (Chicago and Los Angeles, 2003)

Guth, Christine M.E., 'Asobi: Play in the Arts of Japan', *Orientations* (September, 1992), pp. 45–52

Haino Akio, *Ogawa Haritsu: Edo kōgei no sui; Haritsu, Nihon no bijutsu* (Tokyo, 1982) no. 389

Harris, Victor, *Netsuke; The Hull Grundy Collection in the British Museum* (London, British Museum Publications, 1987)

Härtel, Herbert and Marianne Yaldiz (eds), *Along the Ancient Silk Routes: Central Asian Art from the West Berlin State Museums* (The Metropolitan Museum of Art, New York, exhibition catalogue, 1982)

Hayashi Ryoichi, *The Silk Road and the Shoso-in* (New York, Tokyo, Weatherhill/Heibonsha, 1975)

Hillier, Mary, 'Sessai Unkin Zu Fu (Book of Designs) by Sessai Unkin; A Famous 19th Century Netsuke Carver and his Work', *Oriental Art*, (Autumn 1975), New Series vol. XXI, no. 3, pp. 252–8.

Hillier, Jack, *Source-Books for Japanese Craftsmen*, A Lecture given at the London Convention 1978 'Netsuke in Japanese Art' (London, Han-shan Tang Ltd, 1979)

Hillier, Jack, *The Art of Hokusai in Book Illustration* (London, Philip

Wilson Publishers Ltd, for Sotheby Parke Bernet Publications, 1980)

Hopkins, Dr Jay E., 'Early Elephant Ivory Netsuke', *Netsuke Kenkyukai Study Journal* (June 1982), vol. 2, no. 2, pp. 7–18

Hopkins, Dr Jay E., 'Staghorn Figure Netsuke', *Netsuke Kenkyukai Study Journal* (December 1982), vol. 2, no. 4, pp. 7–16

Huish, Marcus B., *Japan and its Art* (London, The Fine Art Society Ltd, 1892)

Hutt, Julia, *Japanese Inrō* (London, V&A Publications, 1997)

Ichimichi Kazutoyo, 'Naito Toyomasa: Part I', *International Netsuke Society Journal* (Winter 2000), vol. 20, no. 4, pp. 21–5

Ichimichi Kazutoyo, 'Naito Toyomasa: Part II', *International Netsuke Society Journal* (Spring 2001), vol. 21, no. 1, pp. 21–9

Ichimichi Kazutoyo (Yuriko Tasaka trans.), 'Naito Toyomasa: Part III', *International Netsuke Society Journal* (Summer 2001), vol. 21, no. 2, pp. 40–5

Japanese Netsuke from Private Collections and Michael Webb Netsuke (London, Eskenazi Limited, 1980)

Jirka-Schmitz, Patrizia, *Netsuke: 112 Masterpieces: The Trumpf Collection* (in German and English), 2 vols (Stuttgart, Staatliches Museum für Völkerkunde and Arnoldische Art publishers, 2000)

Joly, Henri L., *Behrens Collection, Part I, Netsuke* (London, 1912)

Jonas, F.M., *Netsuke* (Rutland/Tokyo, Charles E. Tuttle Company, 1960)

Jonas, F.M., with an introduction by Raymond Bushell, 'Yatate: The Portable Japanese Writing Case', *Netsuke Kenkyukai Study Journal* (Fall 1984), vol. 4, no.3, pp. 10–19

Kawakami Shigeki, 'Ningyō: An Historical Approach', *Ningyō: The Art of the Human Figurine* (Japan Society, New York, exhibition catalogue, 1995), pp. 11–24.

Kazaru korekushion; Netsuke (Osaka Municipal Museum of Art, Osaka, 1982)

Kazaru korekushion senshu (Osaka Municipal Museum of Art, Osaka, exhibition catalogue, 1999)

Kerr, Rose (ed.), *Chinese Art and Design: the T.T. Tsui Gallery of Chinese Art* (London, Victoria and Albert Museum, 1991)

Keyes, Roger and Keiko Mizushima, *The Theatrical World of Osaka Prints* (Philadelphia Museum of Art, Philadelphia, exhibition catalogue, 1973)

Kinoshita, Muneaki, *Netsuke Art of Kinoshita Collection* (Kyoto, Seishu Netsuke Art Museum, 2009)

Kinsey, Miriam, *Contemporary Netsuke* (Rutland, Vermont: Tokyo, Japan, Charles E. Tuttle Company, 1977)

Kinsey, Miriam, *Living Masters of Netsuke* (Tokyo, New York, Kodansha International, 1984)

Kurstin, Joseph, *Netsuke; Story Carvings of Old Japan* (Privately published, 1994)

Kurstin, Joseph, 'An Early 17th Century Screen: Use of Katabori Netsuke in Early 17th Century', *International Netsuke Society Journal* (Summer 2002), vol. 22, no. 2, pp. 16–20

Lawton, Thomas, *Chinese Art of the Warring States Period: Change and Continuity, 480-222 BC* (Freer Gallery of Art, Washington, DC, exhibition catalogue, 1982)

Lazarnick, George (ed.), *The Meinertzhagen Card Index on Netsuke in the Archives of the British Museum* (New York, 1986)

Lazarnick, George, *Netsuke & Inrō Artists and How to Read their Signatures* (2 vols) (Honolulu, 1982)

Liddell, Jill, *The Story of the Kimono* (New York, 1989)

Little, Stephen, with Shawn Eichman, *Taoism and the Arts of China* (The Art Institute of Chicago,

exhibition catalogue, 2000)

Matsura Seizan (Nakamura Yukihiko and Nakano Mitsutoshi, eds), *Kasshi yawa* 1821–1841 (Tokyo, Heibonsha, 1978)

Medley, Margaret, 'The "Illustrated Regulations for Ceremonial Paraphernalia of the Ch'ing Dynasty" in the Victoria and Albert Museum', *Transactions and Proceedings of the Oriental Ceramic Society*, 1957–9, vol. 31, pp. 95–104

Meech, Julia, *Lacquerware from the Weston Collection: a Selection of Inro and Boxes* (Christie's Inc., New York, exhibition catalogue, 1995)

Michaelson, Carol, *Gilded dragons* (The British Museum, London, exhibition catalogue, 1999)

Michener, James A., *The Hokusai Sketch-books; selections from the Manga* (Rutland, Vermont & Tokyo, Japan, Charles E. Tuttle Company Inc., 1974)

Mody, N.H.N., *A Collection of Nagasaki Colour Prints and Paintings Showing the Influence of Chinese and European Art on that of Japan* (London, no date, reprint of 1939)

Nagaoka hanshu Makinoke bosho hakkutsu cho-sa ho-kokusho (Tokyoto Minatoku Kyo-iku Iinkai, 1986)

Netsuke: Japanese Miniature Carvings in the Victoria and Albert Museum (colour microfiche), (Emmett Microform, 1985)

Nihon Netsuke Kenkyukai (ed.), *Netsuke; Edo saimitsu kōgei no hana* (Kanagawa, Nihon Netsuke Kenkyukai, 1995)

Niiseki Kinya, 'Ito-in Japanese Silk Seals: An inspiration for netsuke?', *Arts of Asia* (July–August 1979), vol. 9, no. 4, pp. 130–4

Okada Yuzuru, Netsuke – *A Miniature Art of Japan* (Tokyo, Japan Tourist Library no. 14, 1951)

Okuno Hidekazu (trans. by Nori Watanabe), 'Tanaka Minko: Retained Carver for the Todo Clan of Tsu', *International Netsuke Society Journal* (Fall 1996), vol. 16, no. 3, pp. 16–22

Ouwehand, C., 'Some Notes on ichi-i ittōbori', *The Fascinating World of the Japanese Artist* (The Hague, 1971), pp. 36–40

Pekarik, Andrew J., *Japanese Lacquer, 1600–1900* (The Metropolitan Museum of Art, New York, exhibition catalogue, 1980)

de Perthuis, Bruno, 'Historique des Collections de Netsuke de 1875 à 1983; I^re Partie– 1875 – 1940', *Bulletin Société Franco-Japonaise* (December 1983), no. 3, pp. 21–7

de Perthuis, Bruno, 'Historique des Collections de Netsuke de 1875 à 1983; 2^e Partie– 1940 – 1966', *Bulletin Société Franco-Japonaise* (March 1984), no. 4, pp. 34–40

de Perthuis, Bruno, 'Historique des Collections de Netsuke; Vente Hindson 1967–1969', *Bulletin Société Franco-Japonaise* (May 1984), no. 5, pp. 13–23

de Perthuis, Bruno, 'Historique des Collections de Netsuke de 1875 à 1983; 4^e Partie– 1970–1979', *Bulletin Société Franco-Japonaise* (September 1984), no. 6, pp. 9–17

de Perthuis, Bruno, 'Historique des Collections de Netsuke de 1875 à 1983; 5^e Partie– 1979 – 1983', *Bulletin Société Franco-Japonaise* (December 1984), no. 7, pp. 11–22

Philippi, Donald L., translated with an introduction and notes, *Kojiki* (Tokyo, University of Tokyo Press, 1968)

Reikichi Ueda, *Netsuke no Kenkyū* (Osaka, 1954)

Sandfield, Norman L. (compiled by), *The Ultimate Netsuke Bibliography; An Annotated Guide to Miniature Japanese Carvings* (Chicago, Privately published, 1999)

Netsuke chokoku; Edo no share (Sato Art Museum, Toyama, exhibition catalogue, 1998)

Schwarz, Karl M., *Netsuke Subjects* (Wien, Köln, Weimar, Böhlau, 1992)

Screech, Timon (Takayama Hiroshi trans.), Ō-Edo ijin ōrai (Tokyo, Maruzen, 1995)

Sekido Kengo (trans. Nori Watanabe), 'Ohara Mitsuhiro', International Netsuke Society Journal (Spring 1997), vol. 17, no. 1, pp. 26–31

Sekido Kengo, 'Hojitsu; un maître de Netsuke d'Edo' (in French and English), Bulletin Association Franco-Japonaise (April 1999), no. 64, pp. 27–36

Shaw, Guy, 'Guy Shaw on his Netsuke', Netsuke Kenkyukai Study Journal (Spring 1990), vol. 10, no. 1, pp. 9–16

Shen, Congwen, Zhongguo gudai fushi yanjiu (Hong Kong, 1981)

Shimatani Yoichi, 'Matsuda Sukenaga; His Legend and Mystery', International Netsuke Society Journal (Summer 1996), vol. 16, no. 2, pp. 30–7

Shimatani Yoichi (Nori Watanabe trans. and ed.), 'Red Robe Kokusai', International Netsuke Society Journal (Summer 1999), vol. 19, no. 2, pp. 29–45

Shimatani Yoichi (Nori Watanabe trans. and ed.), 'Red Robe Kokusai, Part II', International Netsuke Society Journal (Fall 1999), vol. 20, no. 3, pp. 28–41

Shimatani Yoichi, 'Genkosai', International Netsuke Society Journal (Summer 2004), vol. 23, no. 2, pp. 26–9

Shimatani Yoichi, 'Eguro Family Carving History', International Netsuke Society Journal (Summer 2004), vol. 23, no. 2, pp.44–50

Smith, Lawrence, 'The Art and Antiquities of Japan', Caygill, Marjorie and John Cherry (ed.), A.W. Franks; Nineteenth-Century Collecting and The British Museum (London, British Museum Press, 1997)

Snowman, R.Kenneth, Carl Fabergé: Goldsmith to the Imperial Court of Russia (London, Debretts Ltd., 1979)

Szeszler, Denis, 'In Search of the "Hungarian Netsuke"', Netsuke Kenkyukai Study Journal (Winter 1988), vol. 8. no. 4, pp. 26–9

Takamado, Norohito, Contemporary Netsuke: The H.I.H. Prince Takamado Collection (Tokyo, 2003)

Princess Takamado, The H.I.H. Prince Takamado Collection II (Kyoto, 2006)

Takamado, Princess Hisako of, Netsuke: Have Netsuke will Travel – H.I.H. Princess Takamado Contemporary Netsuke Collection (Tokyo, Kodansha, 2008)

Tanaka Tomikichi (Robert Hori trans.), 'History of Tobacco Pouches', Netsuke Kenkyukai Study Journal (Winter 1990), vol. 10, no. 4, pp. 8–18

Temple, Charles R. (trans. by Mikoshiba Misao), Takarabukuro (Treasure Bag): A Netsuke Artist Notebook by Mitsuhiro

Tsuchiya, Noriko, Netsuke: 100 Miniatures from Japan, (London, British Museum Press, 2014)

Wang, Loretta H., The Chinese Purse (Taiwan, 1986)

Watanabe Nori, 'News from Japan', International Netsuke Society Journal (Fall 1999), vol. 19, no. 3, pp. 9–11

Watanabe Nori, 'News from Japan: Yoshimura Shuzan', International Netsuke Society Journal (Winter 1999), vol. 19, no. 4, pp. 19–21

Watson, William (ed.), The Great Japan Exhibition; Art of the Edo Period 1600–1868 (Royal Academy of Arts, London, exhibition catalogue, 1981)

Watson, William (ed.), Chinese Ivories from the Shang to the Qing (The British Museum, London, exhibition organized by the Oriental Ceramic Society, 1984)

Welch, Matthew and Sharen Chappell, Netsuke: The Japanese Art of Miniature Carving (The Minneapolis Institute of Art, Minneapolis, Minnesota, exhibition catalogue, 1999)

White, Julia M. and Emma C. Bunker, Adornment for Eternity: Status and Rank in Chinese Ornament (Denver Art Museum, Denver, exhibition catalogue, 1994)

Whitfield, Roderick (ed.), Treasures from Korea: Art through 5000 Years (The British Museum, London, exhibition catalogue, 1984)

Wrangham, E.A., 'Painters Recorded in Inro Designs. Kano to Koma', Netsuke Kenkyukai Study Journal (Summer 1987), vol. 7, no. 2, pp. 10–19

Yamada, Masayoshi, Gendai Netsuke: Netsuke; Modern Masterpieces (in Japanese and English), (Nichibou Shuppansha, 1989)

Yanagi, Reiko (ed.), Inro and Netsuke (Takayama, Inrō Museum, 1992)

Yoshio, Akio, '"Drinking" Tobacco: The Customs and Aesthetics of Smoking in Early Modern Japan', Beverages in Early Modern Japan and their International Context, 1660s–1920s, a conference organized by the Sainsbury Institute for the Study of Japanese Arts and Cultures, SOAS, London, 9–11 March 2001, lecture handout p. 2.

Index